The King's Head

Charles I: King and Martyr

Jane Roberts

with a note on portrait busts by
Jonathan Marsden

First published 1999 by Royal Collection Enterprises Limited,
St James's Palace, London SW1A 1JR

Reprinted 1999

http://www.royal.gov.uk

ISBN 1 902163 93 1

A catalogue record for this book is available from the British Library.

Typeset in 10pt Bembo.
Designed and produced by Book Production Consultants plc, 25–27 High Street, Chesterton, Cambridge CB4 1ND
Printed and bound in Italy by Grafiche Milani

This publication accompanies an exhibition held at The Queen's Gallery, Buckingham Palace, 29 January–3 May 1999
and (in modified form) at the Palace of Holyroodhouse, 1 October 1999–31 March 2000.

ACKNOWLEDGEMENTS
The authors and publisher are grateful for permission to illustrate the following items,
which are not part of the Royal Collection: fig. 19 (©Photo RMN),
fig. 20 (©National Gallery), fig. 39 (Copyright reserved/National Portrait Gallery, London),
fig. 42 (reproduced by permission of the Trustees of the British Museum), fig. 46 (The Trustees of the Berkeley Will Trust,
photograph Courtauld Institute)

This exhibition was selected and organised with the assistance of Martin Clayton, Jonathan Marsden and Theresa-Mary Morton.
The authors are also grateful to the following for their help: Charles Avery, Genevieve Bresc-Bautier, Laurence Brown,
Timothy Clayton, Thomas P. Ford, Kate Gibson, Antony Griffiths, Alastair Laing, Ronald Lightbown, Stephen Lloyd,
Julie Mellby, Oliver Millar, Carl Nix, John Roger Paas, Heiner Protzmann, Graham Reynolds, Guilhem Scherf,
Frits Scholten, Michael Sharp, Richard Sharp, Helen Smailes, Georgina Stonor, Luke Syson, Steven Tomlinson, Bridget Wright

FRONT COVER: Sir Anthony van Dyck, *Charles I in three positions*, 1635 (no. 5 detail)

BACK COVER: Anonymous, *Fairfax with the head of Charles I, c.*1650s (no. 95)

Introduction

The death of Charles I on the scaffold at Whitehall 350 years ago, on 30 January 1649, has bestowed a particular pathos and fascination on both his life and his portraiture. The King was passionately interested in the fine arts and assembled an extraordinarily rich collection of paintings and sculpture. For Rubens he was 'le prince le plus amateur qui soit au monde' – the greatest art-lover among the princes of the world.[1] In the course of his life, which spanned the first half of the seventeenth century, he commissioned works – including portraits – from some of the most brilliant artists ever to find employment with the British crown. These artefacts had to hold their own with the paintings by Titian or sculpted portraits of Roman emperors in the King's collection. They incorporated images of the King ruling triumphant. The reality of the King's reign, and in particular the period 1639–49, was of course rather different.[2]

This publication accompanies a selection of nearly 150 works from the Royal Collection, most of which were produced within the King's lifetime. Together they present us with the picture by which his contemporaries would have recognised their King. This is the first time that the iconography of a single monarch has been the subject of an exhibition at The Queen's Gallery, although Charles I's portraiture has featured in a number of previous exhibitions, particularly *Van Dyck* (1968) and *Kings and Queens* (1982); it was also a key element of other exhibitions curated by Sir Oliver Millar, including *The Age of Charles I* at the Tate Gallery (1972) and *Van Dyck in England* at the National Portrait Gallery (1982–3).

Although the paintings included in the exhibition are generally well-known, most of the prints, books and smaller items have never before been exhibited. Charles I's extraordinary art collection is scarcely touched upon although a number of the exhibits once belonged to the King (see p. 42).

The King's appearance was described by many contemporaries. In his early years he was considered small for his age and physically weak. The fair Stuart colouring is recorded in early miniature portraits including no. 9 (pl. 6), which has a lock of blonde hair set into the back of the frame. In April 1613, the Venetian ambassador in London reported that Prince Charles 'is growing fair as a flower, and in the few months since the death of Prince Henry, he has developed greatly in body'.[3] Although he gained in strength, stamina and self-confidence, both Charles and his wife (Henrietta Maria) remained small in stature: the King was no more than 5 feet 4 inches tall (1.62 m), in striking contrast to his son Charles II who measured over 6 feet (1.83 m). With maturity his hair darkened to brown, and his lips became thicker. Charles's eyes were grey, 'quick and penetrating'.[4] In his early years he adopted the extravagant fashion favoured by his father, but in maturity he was 'sober in apparel, clean and neat'.[5] The task of the royal artists was to transform the short, weak-looking prince into a king.[6]

In portraits of the mature Charles, the following features may be observed: the growth of a slender moustache (*c.*1620: pl. 6:11), which then increased in size (1623: fig. 11) before being accompanied by a neat pointed beard which appeared immediately after the Spanish visit (figs 5, 24). In the 1640s the beard diminished to a patch of hair under the lower lip (pl. 7:18) although by the time of the King's trial it had spread to cover the jawbone and lower cheeks (fig. 22). The rigid horizontal ruff (from *c.*1616: pl. 6:10) was exchanged for one angled towards the shoulders from 1621 (pl. 6:12). The King occasionally wore a single ear-ring in his left ear, both as Prince (pl. 6:10, 11) and as King (pl. 5; fig. 20). The majority of Van Dyck's portraits show Charles I wearing a broad lace collar that was occasionally even worn over armour (fig. 14). The King's hair was longer on the left

3

than on the right side from c.1631 (pl. 8:119). During the political and military difficulties of the 1640s the hair – on both the head and the chin – becomes both shorter and thinner; the expression is care-worn, the eyes more pronounced and doleful (c.1645: fig. 21, pl. 7:18). The King's face appears increasingly long and narrow in Van Dyck's portraits. A long face is a melancholy one and it was reported that when Bernini was confronted with Van Dyck's triple portrait (pl. 5) in 1636 he was struck by 'something of funest [lamentable] and unhappy'.[7]

In his youth Charles was shown in ornate armour with a ruff at the neck (pl. 6); by the mid-1630s this has become the armour of an active military leader, with the short collar of his undershirt falling over the top of the breastplate (e.g. fig. 20). Another late portrait type (that of Van Dyck's Dresden portrait of 1637) shows the King in a cloak with the giant star of the Order of the Garter on the shoulder, as specified in a royal edict of 1627.[8] The chivalric Order was dear to Charles I's heart; he was rarely shown without its blue ribbon, from which the medallion or badge of the Order (the Lesser George) was suspended.

Charles I was only the second member of the Stuart dynasty to rule in England. His father, James VI of Scotland, had travelled south to take over the government of England (as James I) in 1603. With his accession the crowns were united for the first time. The numerous portraits that were produced of members of James I's family put a face to the Stuart name. The King's portraiture must also be seen in the context of the theory of the Divine Right of Kings, in which both Charles I and James I believed profoundly. As God's representative on Earth, they had a preordained responsibility to preserve the true doctrine of the Christian religion, represented since the reign of Henry VIII by the Church of England.

In order to examine the way in which the King's physical appearance was known to his contemporaries the surviving images have been broadly divided into those produced for the King – the court image – and those produced for popular consumption. Within these divisions there are further categories: the more private cabinet pieces and works intended to impress; and works (particularly prints and medals) published with official approval as opposed to the truly popular images.

The category of portraits produced for the King himself includes the smaller works kept in the royal cabinet room, the coins, medals and portrait miniatures. Earlier examples of these art forms were also collected and treasured by Charles I and were supplemented by newly commissioned work. While the art of the portrait medal had only reached England in the late sixteenth century, that of the portrait miniature had arrived almost exactly one hundred years before Charles's accession and had blossomed in the reign of Elizabeth I; the two were closely linked and Nicholas Hilliard, today best known as a miniaturist, was also an engraver and medallist. Englishmen were used to studying and handling these tiny portraits, which had become a normal feature of courtly life: thus James I kept a miniature of George Villiers, Duke of Buckingham, on a blue ribbon, 'under his waistcoat next his breast – to shew the favorit esteem he had for him',[9] and soon after his arrival in England Van Dyck was presented with a diamond-framed miniature of Charles I.[10] These small-scale portraits would normally have been produced under instructions from the King, for the enjoyment of those with whom he chose to share them.

As in the previous reign, many of the artists responsible for both the creation and the dissemination of Charles I's image were not British-born.[11] Simon and Willem de Passe, Mytens, Van Dyck, Van Voerst, Vorsterman, Christian van Vianen and Abraham van der Doort were only some of those who travelled to England from the Low Countries, while the visitors from France included Isaac and Peter Oliver, Jean Petitot, Hubert Le Sueur and the medallist Nicolas Briot. Wenceslaus Hollar, whose etchings provide such a vivid picture of mid-seventeenth-century England, came to England from Germany, but was a native of Prague.

Fig. 1 Daniel Mytens, *Charles I*, 1628 (no. 1)

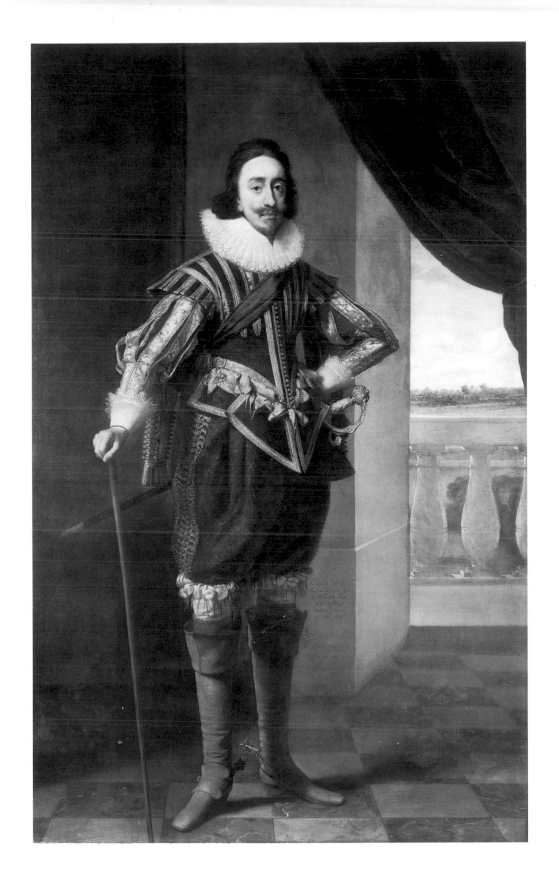

Chronological Table

NOTE: References and images relate to Charles I unless otherwise stated

1600	Birth at Dunfermline (November 19), third child of James VI of Scotland and Anne of Denmark; named Duke of Albany
1603	Death of Elizabeth I and accession of Charles's father as James I of England
1605	Created Duke of York
1609	Birth of Henrietta Maria, youngest child of Henri IV of France and Marie de' Medici
1611	Created Knight of the Garter
1610/11	First oil portraits. Hilliard's miniature (see pl. 6:9)
1612	Death of elder brother, Henry, Prince of Wales (b. 1594)
1613	Marriage of sister, Elizabeth (b. 1596), to Frederick V of Bohemia (February). Peake's portrait following visit to Cambridge (March); engraved portraits by Boel and De Passe studio (fig. 2)
*c.*1616	Isaac Oliver's miniature of Charles as Duke of York (pl. 6:10)
1616	Created Prince of Wales (November). Arrival of Simon de Passe; his portrait registered with Stationers' Company (December; fig. 3)
1617	Death of Isaac Oliver; son Peter Oliver succeeds as court miniaturist
1618	Daniel Mytens arrives from Netherlands
1620	Battle of White Mountain; defeat and exile of Frederick V and Elizabeth of Bohemia
1621	Start of Charles's close relationship with George Villiers, later First Duke of Buckingham. Peter Oliver's miniature (pl. 6:12). Departure of Simon de Passe; arrival of Willem de Passe
1621–3	Negotiations concerning betrothal to Spanish Infanta Maria, sister of Philip IV of Spain
1623	Charles and Buckingham visit Madrid (March–August); failure of plans for Spanish match
1624	Betrothal to Henrietta Maria (November)
1625	War with Spain to 1630

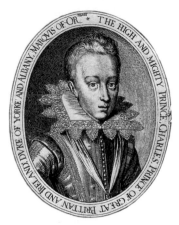

Fig. 2 *c.*1613 by unknown engraver (no. 27 detail)

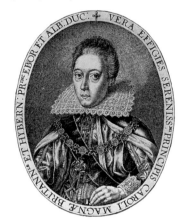

Fig. 3 1616, by Simon de Passe (no. 31 detail)

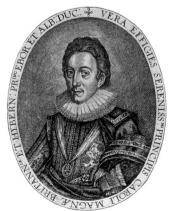

Fig. 4 *c.*1622, by Simon de Passe and unknown engraver (no. 33 detail)

1625 Death of James I (March); accession as Charles I. Marriage to Henrietta Maria (May–June). Appointment of court artists including Mytens and Abraham van der Doort; arrival of Hubert Le Sueur and Nicolas Briot from France

1626 Briot's coronation medal (pl. 8:118)

1627–9 War with France; inglorious peace

1628 Assassination of Buckingham (August). Charles's purchase of Duke of Mantua's collection. Mytens's full-length portrait (fig. 1) and Delff's engraving of it (fig. 32). Briot's privilege to design 'the effigy of the King's image'

1629 Charles dissolves Parliament (March): start of Personal Rule. Birth and death (May) of first child, Charles. Rubens's ceiling for Banqueting House

1630 Peace with Spain. Birth (May) of first surviving child, later Charles II. First *Dominion of the Sea* medal

1630–2 Mytens's double portrait (fig. 15)

1630–3 Le Sueur's equestrian monument (fig. 39)

1632 Arrival of Van Dyck (April); Charles knights him (July), and appoints him Principal Painter in Ordinary; Van Dyck paid for ten works (August), including family group ('*Great Piece*', fig. 17); also paints double portrait. Hendrick Pot visits London (see pl. 4, fig. 12)

1633 Birth (May) of second son, James (later James II). Edinburgh Coronation of Charles as King of Scotland (June). Van Dyck's *Charles I with M. de St Antoine* (fig. 14); Van Dyck paid for nine portraits of Charles and Henrietta Maria (May) and receives annual pension of £200 (October). Briot appointed Chief Engraver to the Mint in England

1634 Imposition of 'Ship Money'. Departure of Mytens. Van Voerst's engraving of Van Dyck's double portrait (fig. 16)

1635 Construction of causeway at Blackfriars to enable Charles to visit Van Dyck's studio (June–July). Van Dyck's *Three eldest children of Charles I* and *Charles I in three positions* (pl. 5); the latter sent to Bernini in Rome

1636 Van Dyck's state portrait (fig. 19). Bernini's sculpted bust nearing completion (June). Death of Robert van Voerst (October). Arrival of Wenceslaus Hollar (December), Dieussart and Jean Petitot

1637 Arrival of Bernini's bust (July). Van Dyck's Dresden portrait

*c.*1637–8 Van Dyck's armed equestrian portrait (fig. 20)

1638 Scots sign National Covenant, pledged to Presbyterianism. Visit of Marie de' Medici (November; see nos 60–2, 104). Van Dyck's oil sketch of Charles and Knights of the Garter and his memorandum listing 25 paintings for which he has not been paid

1638–9 Inventory of Charles's collection by Abraham van der Doort (died 1640)

Fig. 5 1625, by ?Renold Elstrack (no. 40 detail)

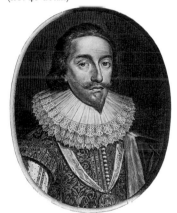

Fig. 6 1626, by Crispijn van den Queboorn (no. 46 detail)

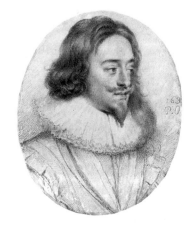

Fig. 7 *c.*1630, by Peter Oliver after Mytens (no. 15)

1639	First Bishops' War (Scottish War): Hollar accompanies Arundel during conflict (see figs 30–1). Second *Dominion of the Sea* medal (September; pl. 8:124)
1640	John Hoskins awarded £200 annuity (March). Charles recalls Parliament (Short Parliament: April–May); Second Bishops' War (August–October); start of Long Parliament (November); machinery of personal government dismantled
1641	Trial and execution of Charles's adviser Earl of Strafford (April–May; see no. 69). Death of Van Dyck in London (December)
1642	Charles's attempted arrest of Five Members of Parliament (January). First skirmishes in Civil War (July); Charles raises Royal Standard at Nottingham (August); Battle of Edgehill (October). Charles leaves London, soon settling in Oxford (until April 1646)
c.1643/44	Petitot returns to France
1643	Year of royalist successes. Rawlins appointed Engraver to the Mint (in Oxford)
c.1644	William Dobson's portrait (fig. 21)
1644	Defeat of royalists at Marston Moor (July). Hollar departs for Antwerp
1645	Execution of Archbishop Laud (January). Charles's defeat at Naseby (June; see no. 74)
1646	Charles surrenders to Scots at Newark (May), following siege (see no. 75). Death of Briot in Oxford
1647	Scots hand Charles to Parliamentarians (January); Charles held prisoner at Holmby, Northamptonshire (February–June; see fig. 33) and Hampton Court (June). Lely's double portrait of Charles and Duke of York. Charles's flight and captivity at Carisbrooke Castle (November). Death of Peter Oliver
1648	Defeat of Scottish army at Preston (August). Charles to Windsor (December). Rawlins to France (to 1652)
1649	Trial at Westminster Hall (January 20–27) and Bower's portrait (fig. 22). Execution at Whitehall (January 30). Publication in London of *Eikon Basilike* (February; nos 106, 107, see fig. 35). Act abolishing the kingly office (March; no. 78). Engraved record of execution published Amsterdam, in *Theatrum Tragicum* (?April). Act declaring a republic (the 'Commonwealth'), under Oliver Cromwell (May; no. 79). Act for sale of the late King's Goods (July). Hollar's memorial portrait (fig. 9)
1653	Oliver Cromwell declared Lord Protector
1658	Death of Oliver Cromwell
1660	Restoration of the monarchy under Charles II (May). Trial of regicides

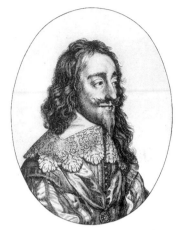

Fig. 8 1641, by Wenceslaus Hollar after Van Dyck (no. 67 detail)

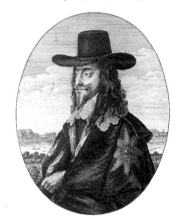

Fig. 9 1649, by Wenceslaus Hollar after Van Dyck (no. 82 detail)

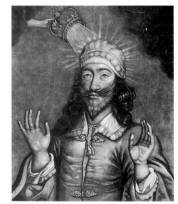

Fig. 10 c.1680, by William Faithorne II (no. 100 detail)

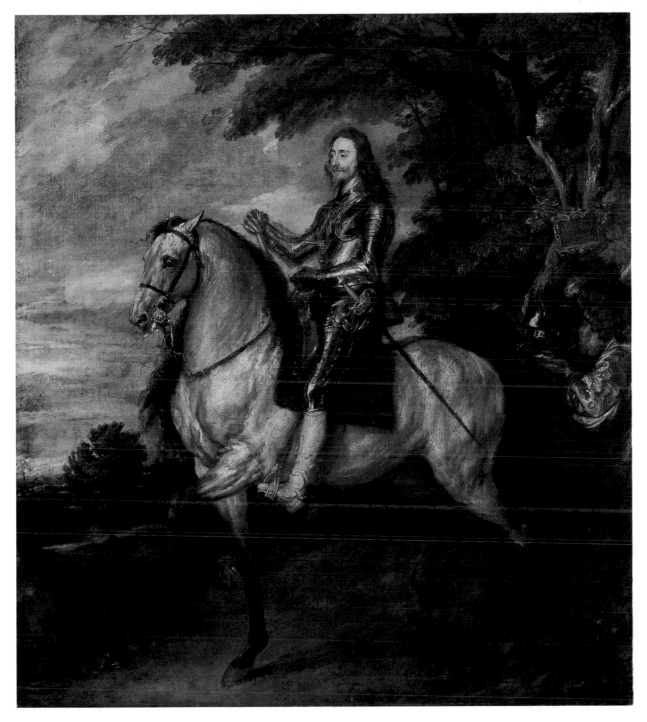

ABOVE: **Plate 1** Sir Anthony van Dyck, *Charles I on horseback*, *c*.1637/8 (no. 6)

OVERLEAF, LEFT: **Plate 2** Daniel Mytens, *Charles I*, 1628 (no. 1 detail)

OVERLEAF, RIGHT: **Plate 3** Daniel Mytens, *Charles I* (from the double portrait), 1630–2 (no. 2 detail)

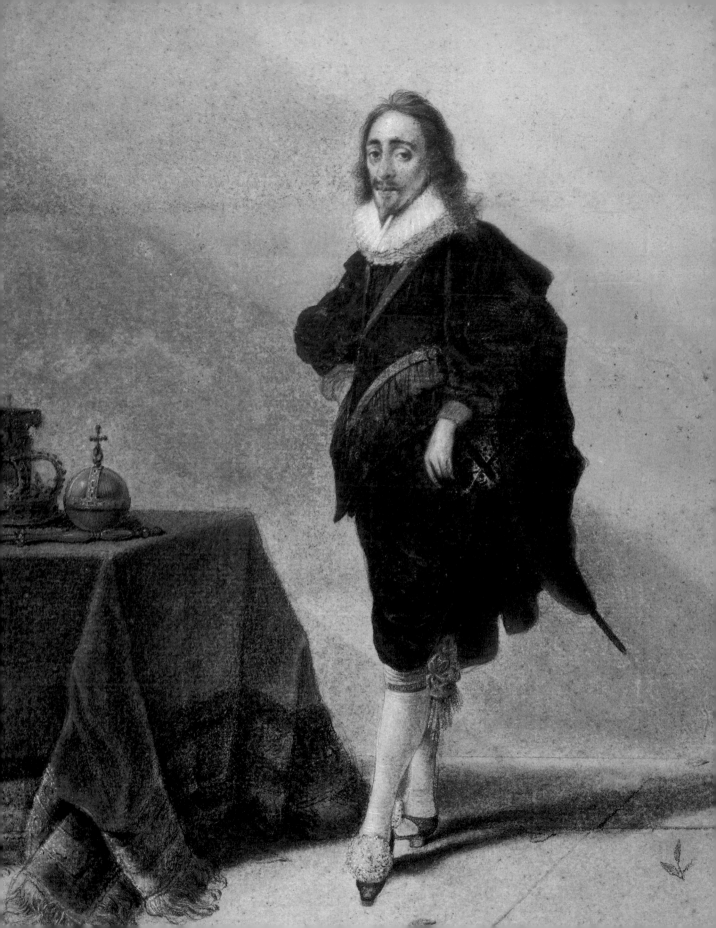

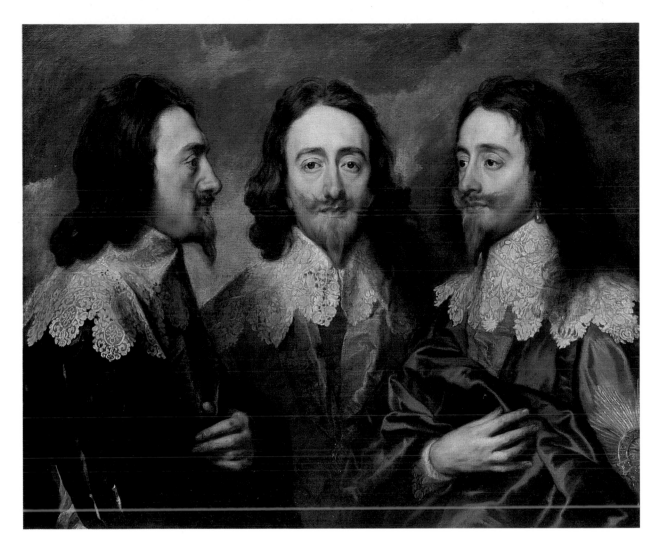

LEFT: **Plate 4** Hendrick Pot, *Charles I*, 1632 (no. 23 detail)

ABOVE: **Plate 5** Sir Anthony van Dyck, *Charles I in three positions*, 1635 (no. 5)

OVERLEAF, LEFT: **Plate 6** Miniatures of Charles I as Prince (*c*.1611–23): no. 9 circle of Nicholas Hilliard, *c*.1611; no. 10 by Isaac Oliver, *c*.1616; no. 11 by Peter Oliver, *c*.1620; no. 12 by Peter Oliver, 1621; no. 13 by Peter Oliver, *c*.1622/3

OVERLEAF, RIGHT: **Plate 7** Later miniatures and enamels of Charles I (*c*.1625–1700): no. 14 by Peter Oliver after Mytens, *c*.1625/30; no. 16 attributed to John Hoskins, *c*.1634; no. 17 attributed to Jean Petitot, *c*.1642; no. 18 by John Hoskins, *c*.1645; no. 19 style of Petitot after Van Dyck, *c*.1650–1700; no. 20 after Van Dyck, *c*.1650–1700

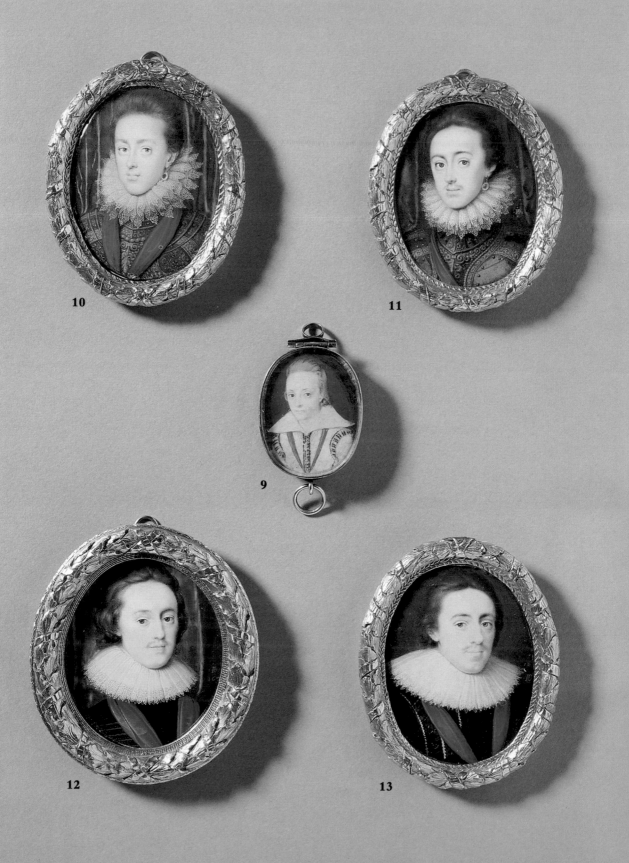

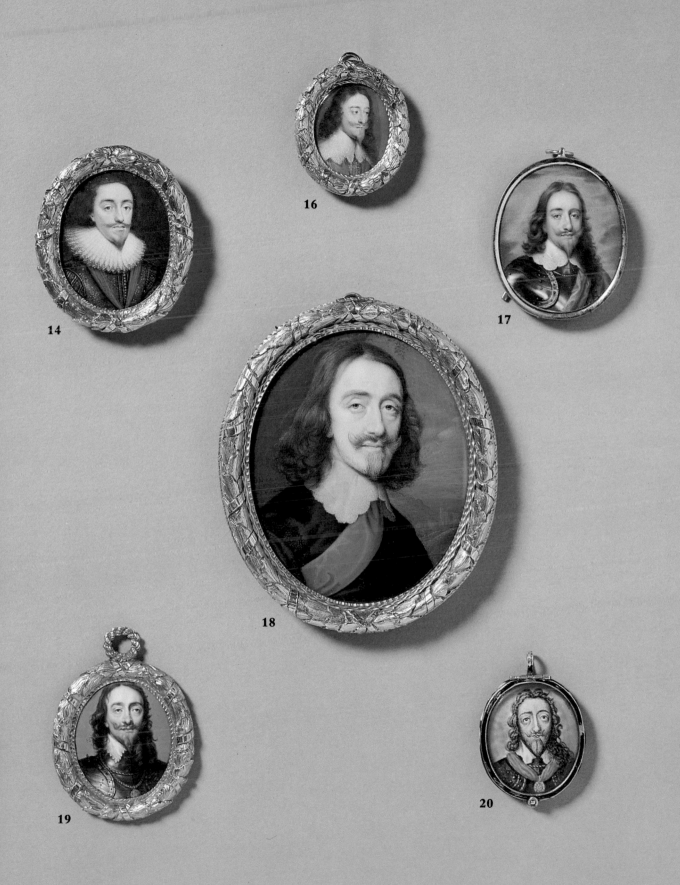

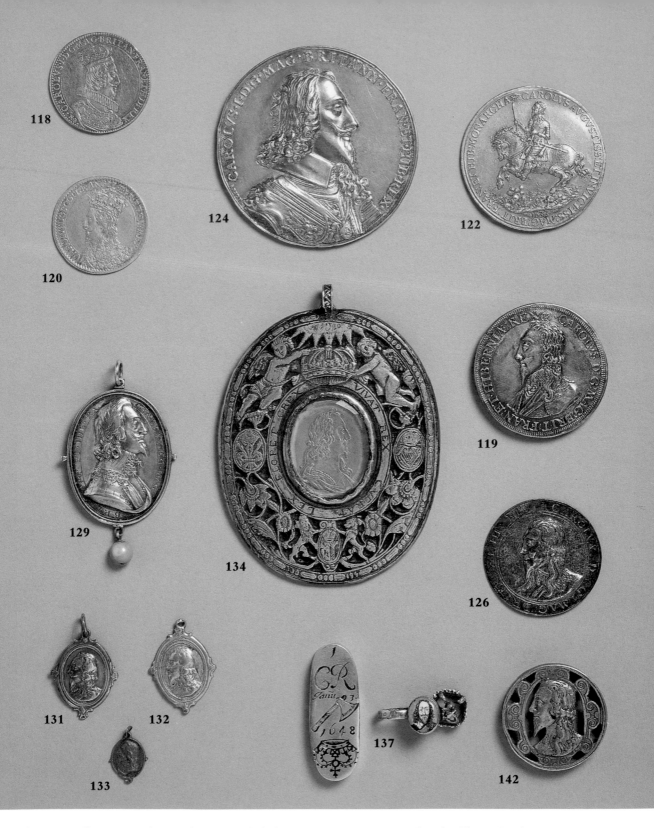

Plate 8 Miscellaneous items bearing the portrait of Charles I (1626–1650s): no. 118 by Nicolas Briot, 1626; no. 119 attributed to Abraham van der Doort, 1631–2; no. 120 by Nicolas Briot, 1633; no.122 by Nicolas Briot, 1633; no.124 by Nicolas Briot, 1639; no.126 attributed to Thomas Rawlins, 1630s–40s; no.129 by Thomas Rawlins, 1640s; nos 131–3 attributed to Thomas Rawlins, 1640s; no.134, late seventeenth century; no.137, 1650s; no.142 (lid only), 1630s

The Creation of the Image: the Court Portrait

From Birth to Accession, 1600–1625

In the first decade of the seventeenth century court artists were more concerned with recording the features of the King and Queen and their elder children – Henry, Prince of Wales and Elizabeth, later Queen of Bohemia – than with the weak and sickly Prince Charles. The painters who worked for King James included the Netherlanders John de Critz the Elder, Sergeant Painter from 1605 until his death in 1642, and his brother-in-law Marcus Gheeraerts the Younger, who worked for the Crown between 1611 and 1618. Robert Peake shared the position of Sergeant Painter with De Critz (and probably also Gheeraerts) from 1610. Each of these artists was responsible for portraying the young Prince Charles, although no such portrait has survived in the Royal Collection.[12]

Henry, Prince of Wales, died unexpectedly in 1612, at the age of 18. During his short life the Prince had accumulated a large number of works of art, books, coins and medals which now passed to his younger brother. Between 1612 and November 1616 Prince Charles, although now heir to the throne, was correctly styled Duke of York and Albany; he was not named Prince of Wales until the latter date, but Prince of Wales's feathers often accompanied Charles's portrait from the time of his brother's death (see fig. 25).

The earliest portraits of Prince Charles included in the present selection date from the two or three years either side of 1612. The first is the miniature in the style of Nicholas Hilliard (pl. 6:9), which must date from soon after the Prince's appointment to the Order of the Garter in 1611. On James I's accession to the English throne Hilliard had been confirmed in office as Limner to the King, having already worked for many years in this capacity for Elizabeth I. It is possible that no. 9 is the work of Nicholas's son, Laurence, who later succeeded to his father's official position. The next likeness of the Prince,

from c.1616, is another miniature (pl. 6:10), this time by Hilliard's pupil Isaac Oliver who was married to Gheeraerts's sister.[13] No. 10 appears to be identifiable with the portrait of the King 'when you were Duke of Yorke', described in the inventory of Charles I's collection made by Abraham van der Doort in 1638–9; it may also have been one of the four miniatures 'drawn for the Prince before his Pearson' for which Oliver was paid in April 1617;[14] he died later in the same year. This and the three miniatures (pl. 6:11–13) painted prior to 1625 by Isaac's son, Peter Oliver, form a valuable series of images of the Prince. Nos 11–13 are all signed by Peter Oliver and no. 12 is dated 1621, by which time Peter Oliver was modelling flesh with a new softness and his works no longer have the jewel-like appearance of the Elizabethan miniature.

A new wave of artists arrived in England from the Continent from c.1616. Chief among these were Paul van Somer, who held a virtual monopoly on the portraiture of the King and Queen from 1617 to his death about five years later, also, Abraham van Blijenberch, who was in England at the same period and whose full length portrait of Charles as Prince of Wales was noted by Van der Doort;[15] and Daniel Mytens, the most talented of 'The New Netherlanders'. In August 1618, when his full-length portraits of the Earl and Countess of Arundel were complete, Mytens was attempting to 'fynde occasion to drawe the Princes highnes picteure'. The series of portraits that he subsequently painted of Charles, both before and after his accession, are crucial documents for the state of Stuart portraiture immediately before the arrival of Van Dyck in England (figs 1, 11). The Prince was particularly attached to Mytens: he secured the artist's naturalisation (in August 1624) and appears to have paid the rates on his house in St Martin's Lane throughout Mytens's stay in England.[16]

While Charles was heir to the throne the matter of his future marriage was frequently spoken of. After many years

of discussion about a possible Spanish match, in March 1623 Prince Charles and the Duke of Buckingham travelled incognito to Madrid in the vain hope of confirming arrangements for a marriage between the Prince and the Infanta Maria. The journey was a personal and diplomatic failure although it resulted in the acquisition by Charles of many fine works of art and gave rise to the commissioning of portraits of the Prince for despatch to Spain. Mytens was responsible for at least one of these portraits, a full-length intended for the Spanish Ambassador; it is possible that miniatures such as no. 13 (pl. 6) – painted by Peter Oliver at the time of the Spanish marriage negotiations – were also sent to Spain.

The images that these artists created of the young Prince were intended to impress, both at home and abroad. Like his deceased brother Henry, Charles was presented as the 'High and mighty prince' and the fitting, fair and virtuous successor to his father, and following the latter's death in March 1625 he ascended the throne as King Charles I.

From Accession to Civil War, 1625–1642

Discussions concerning the possible marriage of Charles and another Catholic princess, Henrietta Maria of France, commenced immediately after the Spanish fiasco. In November 1624 the couple became formally betrothed (see fig. 5); the marriage took place soon after Charles's accession.

At about the same time the King's household was formally constituted. It included Daniel Mytens, appointed 'one of our picture-drawers of our Chamber in ordinarie'. Mytens's succession of portrait types, commenced before the accession, were repeated many times, the costume and setting varying from portrait to portrait. No. 1 (fig. 1 and pl. 2) is one of a number of fine autograph full-lengths by Mytens to have survived; it may have come from the collection of the King's sister, Elizabeth of Bohemia. The picture is inscribed *ad vivum. dep. D Mytens. p. Regius 1628* and was evidently painted from life. Curiously, the King owned no portraits of himself by Mytens: they were produced as diplomatic or familial gifts.[17] The portraits were therefore chiefly known in England through workshop replicas and engravings (e.g. fig. 32).

In the late 1620s two other key artists visited England for brief periods: Peter Paul Rubens and Gerrit van Honthorst. Rubens's *Landscape with St George and the Dragon* (Royal Collection) includes portraits of the King and Queen in the figures of St George and the Princess, while Honthorst's *Apollo and Diana* (Royal Collection) shows the Duke of Buckingham (as Mercury) leading a procession of the Liberal Arts to the King and Queen (as Apollo and Diana). Before his departure at the end of 1628 Honthorst was granted an annual pension of £100 for life 'for acceptable services', and was paid £500 for work done for the King. The only surviving independent portrait of Charles I by Honthorst is that in the National Portrait

Fig. 11 Daniel Mytens, *Charles, Prince of Wales*, 1623 (OM 117, detail)

Gallery; this employs an informal pose and is quite distinct from the official likenesses produced by Mytens.[18] No independent portrait of the King is known to have been painted by Rubens.

The early years of Charles I's marriage were not happy, but from the late 1620s (especially after the assassination of the Duke of Buckingham in August 1628) the King became both a fond husband and a devoted father. After the birth of a short-lived first child in 1629, the future Charles II was born in 1630, Princess Mary in 1631 and the future James II in 1633. One month after Prince James's birth, the King travelled north to Edinburgh for his coronation as King of Scotland at Holyroodhouse (see nos 54,

55, 120-3). The splendour of the ceremony, devised by the King and Archbishop Laud, upset the Calvinist community. Meanwhile, popular discontent was growing in the south following the King's decision to rule without Parliament. The King's Personal Rule lasted for eleven years from March 1629. Throughout this time Inigo Jones continued to produce court masques, promoting visions of peace and harmony, which were both expressions of the royal will and mirrors of the royal mind.[19]

The period of the Personal Rule produced some of the finest portraits ever executed in England. However, there was no sharp break with past practice and many of the portraits of Charles I painted at this time continued to follow the old patterns. The King commissioned a number of paintings in which his portrait (or that of his wife) was placed in an elaborate architectural setting. Mytens's first full-length of Charles as King was painted in 1627 onto a

Fig. 12 Hendrick Pot, *Charles I, Henrietta Maria and Charles, Prince of Wales*, 1632 (no. 3)

background perspective completed by Steenwyck in the previous year; this fine amalgam was destined for the King's sister-in-law, the Duchess of Savoy, and remains in Turin.[20] Although in that case the portrait was a fine and original work of art, in general such pictures required little in the way of painterly skills for the portraits tended to be copies of accepted images by others. It is therefore not surprising that Van Dyck had 'no mind' to work in such a way on a large perspective background that in consequence remained empty, in store at Whitehall, at the time of Van der Doort's inventory.[21]

It was probably in the context of this more repetitive work that Cornelius Johnson was sworn in as 'his Majesty's servant in ye quality of Picture Drawer' in December 1632. Although he was granted sittings by the King and Queen in 1633 and was still named as one of the King's 'servants in ordinary of the chamber' in 1641, no portraits of Charles I by Johnson have survived in the Collection. Unlike Van Dyck, Johnson was prepared to insert figures into perspective fantasies for the King, and he also repeated portraits of the King and Queen in miniatures.[22] Another artist who served in this capacity was Van der Doort's assistant and successor as Surveyor, Jan van Belcamp: the figures in fig. 13, based on *ad vivum* portraits by Mytens and Van Dyck, may have been painted by him.

Fig. 13 Unknown artists (?Jan van Belcamp and ?circle of Steenwyck), *An interior with Charles I, Henrietta Maria, Jeffery Hudson and the 3rd and 4th Earls of Pembroke, c.*1635 (no. 4)

The purpose of the visit to England in 1632 by the little-known Dutch artist, Hendrick Pot, is not known, but the journey resulted in one drawing (pl. 4) and two paintings of the King, shown (in fig. 12) with the Queen and their eldest son. Pot's portraits were apparently based on sittings with the King and although not recorded in Charles I's collection, they must have received royal sanction.[23]

While these new artists came and went, Mytens continued in the King's service and produced two important innovative images of the King and Queen together in the years around 1630. In addition to the large hunting picture (Royal Collection[24]), there was the half-length portrait of the King and Queen (fig. 15), painted for the latter's London residence but reworked (particularly in the portrait of the Queen), probably by Van Dyck.[25] Both pictures include a public statement of tenderness and intimacy between the King and his wife, who passes him a laurel wreath in the double portrait. Small branches of laurel and palm were also included in Pot's portrait (fig. 12), to represent the successful union of the children respectively of Henri IV of France (the victorious leader) and James I of England (the peace-maker). Mytens's last important portrait of Charles I was the full length in Garter robes, painted for Lord Wentworth (later Earl of Strafford) in 1633. In the following year the artist returned home to the Netherlands, correctly recognising that he had been displaced from his rôle as first portrait painter to the King.

No artist's name is more closely connected with Charles I than that of Anthony van Dyck, who arrived in London in April 1632.[26] Three months later he was appointed the King's Principal Painter in Ordinary and received a knighthood; in the following year he was granted an annual pension of £200, for life.[27] This was the artist's second visit to London for he had worked for King James in 1620–1; in addition, he had executed a commission for Charles I (a painting of *Rinaldo and Armida*) in Antwerp in 1629. With the exception of the period 1634–5, and brief visits to the Continent in 1640 and 1641, Van Dyck spent the remaining nine years of his life in England, producing the incomparable series of portraits that transformed both the image of Charles I and the rooms in which they were placed: for Van Dyck's paintings were highly valued by the King and – with a few exceptions – were retained by him. The first wave of work undertaken by Van Dyck in England included the large family group (the '*Great Piece*', fig. 17) and the double portrait (Kroměříž; see fig. 16), painted in 1632. In the following year he painted *Charles I with M. de St Antoine* (fig. 14) and a number of smaller portraits of the King and Queen. After the artist's return to the Continent in 1634–5 the series resumes with *The three eldest children of Charles I* (Turin and Royal Collection) and *Charles I in hunting dress* (fig. 18), which may have been painted for one of the

Fig. 14 Sir Anthony van Dyck, *Charles I and M. de St Antoine*, 1633 (OM 143; RCIN 405322)

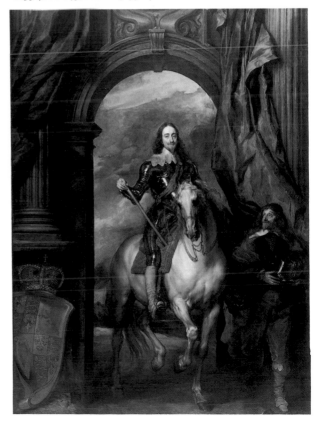

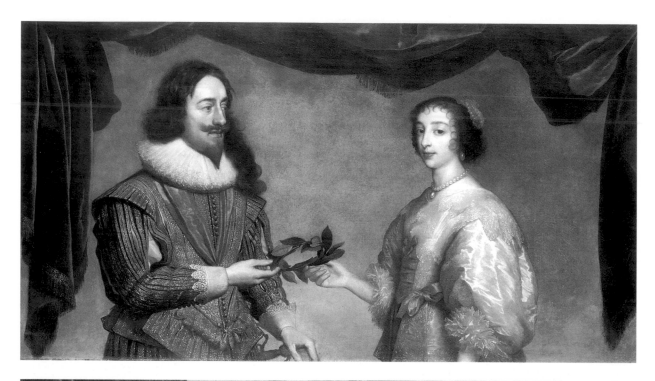

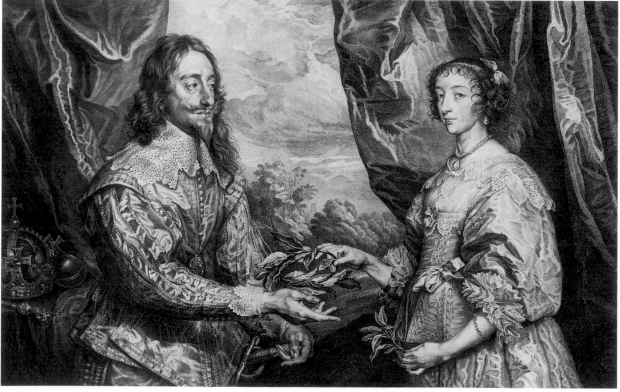

Queen's French relations. In date the picture must be close to the portrait of *Charles I in three positions* (pl. 5), painted in 1635 to enable Bernini to produce a marble portrait bust of the King. The result, nearly complete by June 1636 but not despatched to England until the following year, was one of the most striking pieces of sculpture ever to be made of a British sitter (see below, p. 36ff). In 1636 Van Dyck produced the state portrait of Charles I (fig. 19) and probably also the half-length armed variant of the frontal head from the triple portrait (see fig. 31). These were soon followed by the armed equestrian portrait (fig. 20; see also pl. 1), the half-length portrait of 1637 (Dresden), and the commission for *Charles I and the Knights of the Garter* for the Banqueting House, Whitehall (modello now Belvoir Castle).

In these paintings, Van Dyck transformed English portraiture through the combination of his brilliant handling of paint and his superb draughtsmanship. It was his particular achievement to produce an image of Charles I that was both more lively and more freely painted than those that went before. Although a number of the poses and conventions used in these portraits were not new to Van Dyck, the old formulae were converted by the artist's mastery of baroque design, both on an intimate and on a grand scale. Thus the simple juxtaposition of King and Queen in a double portrait, which appears wooden with Mytens (fig. 15), has a new grandeur with Van Dyck, whose painting appears to have been commissioned specifically to replace Mytens's picture; it is here represented by Van Voerst's engraved copy (fig. 16).

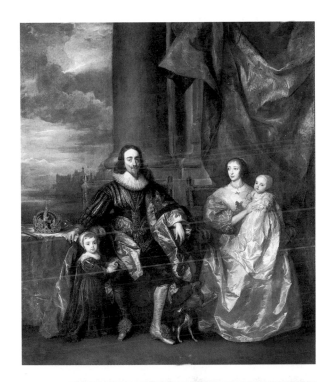

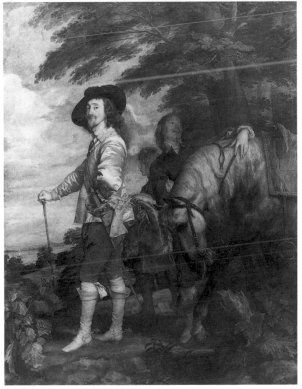

ABOVE LEFT: **Fig. 15** Daniel Mytens, with additions by Van Dyck, *Charles I and Henrietta Maria*, 1630–32 (no. 2)
LOWER LEFT: **Fig. 16** Robert van Voerst after Van Dyck, *Charles I and Henrietta Maria*, 1634 (no. 56, image only)
ABOVE RIGHT: **Fig. 17** Sir Anthony van Dyck, *Charles I, Henrietta Maria and their two eldest children* (the 'Great Piece'), 1632 (OM 150; RCIN 405353)
LOWER RIGHT: **Fig. 18** Sir Anthony van Dyck, *Charles I in hunting dress*, c.1636 (Musée du Louvre, Paris)

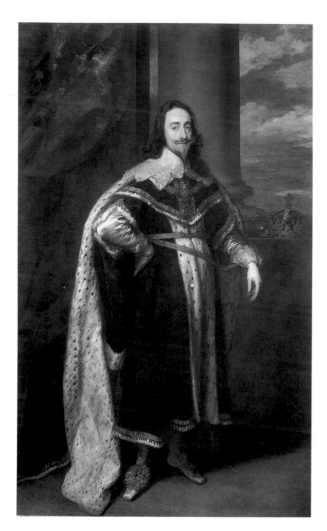

Fig. 19 Sir Anthony van Dyck, *State portrait of Charles I*, 1636 (OM 145; RCIN 404398)

Van Dyck's portraits of Charles I were probably always intended for the prominent locations in which they were later recorded and where they could be 'read' by the King's visitors and those close to the Crown. The 'Great Piece' (fig. 17) was painted for the Long Gallery at Whitehall in 1632 while the equestrian portrait with M. de St Antoine (fig. 14) was placed at the end of the Gallery at St James's Palace, which was the chief place of reception for ambassadors and other important visitors from overseas. A member of the entourage of Marie de' Medici, who

lodged at St James's during her visit to London in 1638, made the following comment on Van Dyck's painting: 'without exaggeration, in preserving the state of this great monarch, [Van Dyck] has so skilfully brought him to life with his brush, that if our eyes alone were to be believed they would boldly assert that the King was alive in this portrait, so vivid is its appearance'.[28] The State Portrait (fig. 19) hung in the Cross Gallery at Somerset House, while the equestrian portrait now in the National Gallery (fig. 20) was hung in the Prince's Gallery at Hampton Court; its modello (pl. 1) was retained at Whitehall.[29]

We can only guess at the processes through which Van Dyck's portraits of Charles I passed in the course of their production. The two men were clearly well acquainted: in 1635 a causeway was constructed at Blackfriars to enable the King to visit Van Dyck's studio and see his paintings. For the most important portraits of himself, the King would have granted the painter sittings, which would have resulted in oil studies, painted directly onto canvas.[30] The subtle variations in facial features were recorded in near-frontal and near-profile poses, and rarely in full-frontal; pure profile was only employed to assist Bernini to create a three-dimensional image (pl. 5). In this creative process drawings appear to have played a minor rôle. Among the few surviving drawings relating to Van Dyck's portraits of Charles I are a full-length study relating to the King's pose in the '*Great Piece*' and a rather stiff head and shoulders study of the King's head, with wide-brimmed hat.[31]

Van Dyck's portrait types proved extremely popular with both the King and his courtiers, who obtained actual-size copies for their own collections.[32] They were also translated into low reliefs by the royal goldsmith Christian van Vianen, who was in England from 1635.[33] Other copies were made by the King's miniaturists, who were increasingly employed to copy – in little – large-scale paintings by other artists, whether contemporary portraits or Old Master paintings. The recently discovered documentation concerning Peter Oliver's royal employment confirms that the artist's production of *ad*

vivum miniature portraits was at its peak in the period from *c.*1620 to 1627, in which year he received an annuity as 'his Ma[ts] Lymner'. Although from 1636 he was entitled to a royal pension of £200 annually, the majority of his later work (including pl. 7:14 and fig. 7) is derivative.[34]

The work of John Hoskins was also closely associated with large-scale portraits by other artists. Thus the small portrait of the King (pl. 7:16) is probably a copy by Hoskins after Van Dyck dating from *c.*1634. Van der Doort noted Hoskins' copy of Van Dyck's double portrait among the contents of the Cabinet Room at Whitehall; that miniature, dated 1636, is now in the collection of the Duke of Northumberland. Hoskins was also responsible for *ad vivum* portraits of the King; one such portrait, specified as 'his owne worke', 7¾ inches high, was exchanged by the King with Lord Pembroke in 1638 and may be identifiable with the miniature signed and dated 1632 in the Beauchamp collection; at the time of this exchange the miniature was copied, by Hoskins himself, for the King.[35] The high value that Charles I attached to the work of Hoskins is indicated by the royal award of an annuity of £200 on condition that the artist did not work for another patron without permission. This grant was made in March 1640 but was only paid once owing to the gradual collapse of the machinery of Charles's government.[36]

In 1636 the last important foreign artist to be employed by the King and Queen arrived in England from France: this was Jean Petitot, the Geneva-born artist who first mastered the art of the portrait enamel.[37] Charles I's rôle as the encourager of this new art form was considerable; in addition, Van Dyck volunteered to show Petitot how to depict the flesh tones with more naturalism. Petitot was a member of Henrietta Maria's household until his return to the Continent in the early 1640s. A miniature on vellum of the King, signed and dated by Petitot in 1636, is in the Northumberland collection; an enamel signed and dated 1638 is in the Welbeck Abbey collection, while signed portraits of the Queen are dated 1638 and 1639. No. 17 (pl. 7) is neither signed nor dated but is close to Petitot's

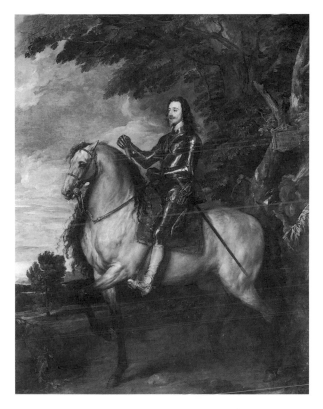

Fig. 20 Sir Anthony van Dyck, *Charles I on horseback, c.*1637/8 (National Gallery, London)

style. Like the Welbeck miniature of the King, it copies the head in a Van Dyck portrait type evolved *c.*1636 but now only known through later variants.[38]

Although the bronze portrait busts by Le Sueur, produced for distribution around the country, are discussed in the following section, two marble busts of the King belong to the category of the court portrait. Bernini's bust (discussed on p. 36ff) was always considered pre-eminent as a work of art: the Inventories and Valuations of the King's Goods made in 1649–51 value it at £800, while Van Dyck's equestrian portraits were considered worth a mere £150 to £200.[39] The second marble bust was produced by the French artist François Dieussart in 1636 and is now at Arundel Castle. Dieussart's bust is closely related to Van Dyck's armed half-length portrait of the King, which may have been painted in the same year.

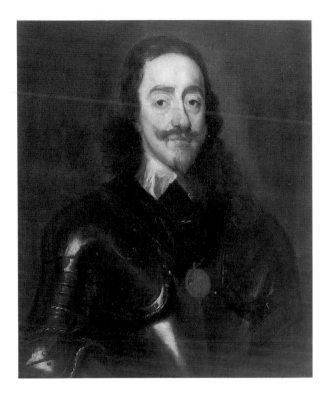

The Final Years, 1642–1649

Van Dyck's death in London in December 1641, shortly before the start of the Civil War, came at a curiously apposite moment. The practice of court portraiture diminished in both scale and importance from the late 1630s. The King's painters gradually dispersed, many moving (or returning) to the Continent. The annual grant of £200 that Van Dyck had received since 1633 was kept in abeyance until soon after the Restoration, when it was entrusted to his lineal successor as royal portraitist, Peter Lely.

In the last eight years of the King's life there were fewer opportunities for him to be portrayed. However, William Dobson – a former pupil of Van Dyck – painted Charles I while the court was based in Oxford. His portrait, which is known in several examples (including fig. 21), is a natural successor to Van Dyck's armed image of the King. Hoskins' fine miniature (pl. 7:18) may date from the same period and also appears to have been made *ad vivum*, unlike so many of the artist's later portraits of the

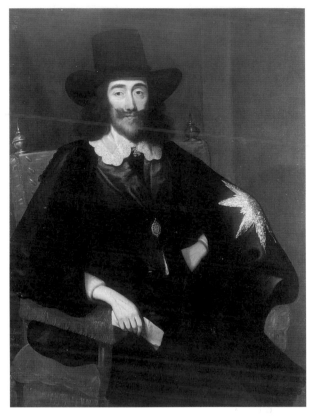

ABOVE LEFT: **Fig. 21** William Dobson, *Charles I in armour*, 1642–6 (no. 7)

ABOVE: **Fig. 22** Edward Bower, *Charles I at his trial*, 1649 (no. 8)

King. While Charles I was confined at Hampton Court in 1647 he was portrayed with his second son, James, by Lely (Northumberland collection). The last artist to portray Charles I alive was Edward Bower, one-time 'servant to Anthony Vandike', who worked up drawings made at the time of the King's trial in January 1649 into a series of oils including no. 8 (fig. 22). Dobson's image is that of a broken man, while Bower's painting shows him resigned to his inevitable fate, only days before his death. It has a different status to the earlier portraits of the King and in some ways belongs to a discussion of the popular rather than the court image. It also looks ahead to the post-Restoration period when repetitions of any available portrait of Charles I found a purchaser.

The Dissemination of the Image: the Popular Portrait

The majority of the King's subjects would have known of his appearance not through oil paintings and miniatures but via smaller-scale objects: coins and medals, royalist badges, prints and – after the King's death in 1649 – the many miscellaneous items which were produced to commemorate him. In most cases the basis for the King's portrait in these minor artefacts is unclear. However, it is occasionally possible to link them to the approved court images discussed above.

The importance of establishing a fitting image of the monarch in the public mind has long been understood. This is one of the reasons that a head symbolising – if not portraying – the reigning monarch is shown on a nation's currency. Coinage was, and remains, protected by the law of the land: to counterfeit, clip, or file the money of England is a treason – although during the Civil War a large number of coins bearing Charles I's head were pierced for use as royalist badges. Like coins, medals, normally in gold and silver, were produced in and distributed from the Royal Mint; however, they were circulated amongst a narrower community.[40] Although the robust medal and the exquisite portrait miniature have in common the fact that they were both treasured in the drawers of collectors' cabinets, medals had a wider circulation than miniatures; they were thus of much more potential significance as a propaganda device.[41] Medals bearing the image of Charles I were produced in advance of both the English and the Scottish Coronations (pl. 8:118, 120), at which events a number were distributed to those attending.[42] The ways in which medals were made available to a wider public are unclear although after the Restoration, Roettiers' medals (including one portraying Charles I) were advertised in newspapers as being available from 'Mr Lane, Goldsmith, at the Rose in Lombard Street; and by several Booksellers and Cutlers in London and Westminster'.[43]

Coins are datable through the mint (or privy) marks which they have by law to bear. Charles I's coinage shows him bearded from the year of his accession (see pl. 8:117). What is notable, however, is how little the King's image on his early coins and medals accords with that found in other media. The 1626 Coronation medal (pl. 8:118) shows a full-cheeked, curly-headed monarch quite unlike the sitter in Mytens's portraits of these years (e.g. figs 1, 11). The 1639 Dominion of the Sea medal (pl. 8:124)[44] is the first medallic portrait that is comparable with those in other media. The majority of these pieces are the work of Nicolas Briot, who moved to England from France in 1625 having served as Engraver-General of the French coinage for many years. The unfamiliar features given to Charles I on his earliest numismatic portraits may have been transferred from France in Briot's subconscious stock of images. Briot received a privilege to design 'the effigy of the King's image' in 1628 and was chief engraver to the Mint in England from 1633, by which time he had updated the King's likeness.[45] Briot's medallic work includes struck medals of the Royal Family issued in 1635, on the basis of oil paintings by Van Dyck; the King's face in the Dominion of the Sea medal may also have been influenced by a painting by Van Dyck, and specifically the profile head from the triple portrait of 1635 (pl. 5).[46] When Charles II required a Restoration Medal, his portrait was drawn by Samuel Cooper prior to the medal being produced by Jan Roettiers; the production process of Charles I's medals is less easy to fathom.

The 'Juxon medal' has an emotive place in the history of Charles I's reign because it was reputedly given by the King to Archbishop Juxon on the scaffold. It is not in fact a medal but the unused model for a coin; the unique gold pattern piece is now in the British Museum, but is represented here by an electrotype copy (pl. 8:119). The King's portrait in this piece, which is mint-marked

19

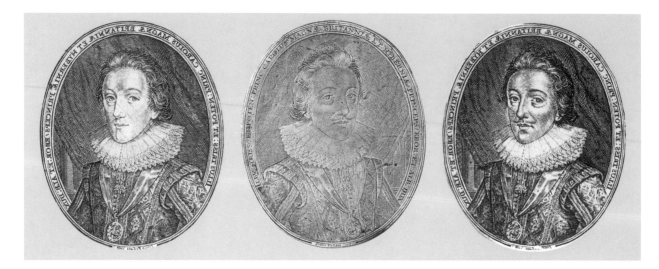

1631–2, is distinct from Briot's pieces and shows the uneven hairstyle that he sported from the early 1630s. It has been attributed to Abraham van der Doort, who was appointed in 1625 to four separate posts in the Royal Household, two of which were concerned with the King's collection, and two with the King's coinage; the King made these appointments on the basis of his sixteen years' knowledge of Van der Doort's skill as a designer of coins. As 'Provider of Patterns' it seems likely that he – rather than Briot – may have been responsible for the King's likeness on the Juxon medal; a particular feature of the piece is its high relief, precisely the defect that prevented Van der Doort's patterns from being put into general use.[47]

The medallic portraiture of Charles I also includes the oval gold and silver plaques produced by Simon de Passe during his residence in England between 1616 and 1621 (see fig. 23). Like the circular medals of the King, these were 'cabinet pieces' in the strictest sense, although none is recorded in the collection of Charles I. As such they may justifiably be considered not as court images but in the context of the popularisation of those images, albeit for a refined and aristocratic market, a context they share with many contemporary prints. These oval plaques should also be seen as the natural successors to the medallions produced in the late sixteenth century by engravers

ABOVE: **Fig. 23** Simon de Passe, *Silver plaque of Charles I when Prince of Wales*, c.1621 (no. 116) with paper impressions taken from a similar plaque before and after reworking (RCIN 601844 and 601499)

RIGHT: **Fig. 24** Willem de Passe, *The family of James VI and I*, c.1623/4 (no. 25)

such as Goltzius and Nicholas Hilliard.[48] The production period of the De Passe plaques partly coincided with Hilliard's monopoly for the engraving of the royal likeness (1617–19).[49] They may therefore have resulted from a licensing agreement between Hilliard and De Passe.

The De Passe family were extraordinarily active in the production of individual prints and series of prints in the first three decades of the seventeenth century. Although the father, Crispijn, was chiefly based in Utrecht, at least two of his sons – Simon and Willem – and possibly also his daughter Margarita worked in England. The first of Simon's prints, a portrait of Henry, Prince of Wales, is dated 1612, four years before he moved to England.[50]

This information may serve to set the scene for Simon de Passe's silver and gold portrait plaques. Although the technique of these plaques has been the subject of much discussion in recent years,[51] their close relationship to De Passe's engraved portraits of Prince

Charles has not been studied in detail. It is clearly the case, however, that the same portrait types served for both plaque and print, and that the changing facial features of the Prince were updated on both (see fig. 23). This is particularly evident with the larger plaque (no. 116) in which the sitter's features are more mature than in the plaque dated 1616 (no. 115), although his titles (inscribed around the rim) are given as Duke of York and Albany, rather than Prince of Wales (which he became in November 1616). If the larger plaque is studied alongside De Passe's portrait of the Prince, first registered in December 1616 (fig. 3), it will be seen that very

similar lettering was used in the prints, and furthermore that the Prince's titles were not changed although his facial features were radically revised at least twice in the period between 1616 and c.1622 (see nos 31–3). Similar but more subtle changes were made to the plaques, to which lines were added to depict the Prince's new moustache, or his changing facial structure. No. 116 is normally dated 1615 or early 1616 but a number of surviving versions of these much-repeated pieces appear to date from several years later, and to show the future King at around the same period as Peter Oliver's early portrait (pl. 6:11), if not a little later. As a companion

21

plaque of the Infanta Maria was also produced by Simon de Passe, it is possible that no. 116 is as late as 1622, at the time of the Spanish marriage negotiations, when his pair of engravings (nos 35, 36) were made.

The small circular plaques or counters (no. 143), also probably produced by the De Passe workshop, were altered and updated in the same way.[52] The precise *raison d'être* of these pieces, most commonly found in silver but also known in gold, is uncertain. The variant sets of 36 circular counters, with full-length figures of the monarchs of England (no. 142), may have served a semi-didactic purpose for the reverses bear details of dates and places of burial. In some ways the status of these counters is therefore similar to that of the prints that made up the *Baziliologia, a Booke of Kings*, published in 1618.[53] In broad terms, these pieces must all have helped to publicise and strengthen the hold of the Stuart line as rulers of England as well as Scotland.

When we move from coins and medals of Charles I to a consideration of contemporary printed images, we must be aware that much of the output of print-makers has perished. The survival rate is associated with function and purpose: a print would have a better chance of survival if it was bound into a book or kept in a portfolio than if it was handled in a pocket or pasted onto a wall. The exhibit with the most 'wear' is the much-folded and rubbed 'Black Memorial' (no. 91), which is apparently unique. Meanwhile, many of the works of Hollar, who was responsible for thirteen prints in this selection, are in pristine condition: these were already being collected in Antwerp in 1648.[54]

Until *c*.1600 London engravers sold their products direct but thereafter print-selling and print-publishing became an established commercial activity which had to serve popular demand in order to survive. The copper plate bearing the engraved image was part of the print-seller's capital. Engravers were employed not only to engrave the original plate but also to update old plates. Portraits were a staple of most print-sellers' stock and royal portraits appear to have had a certain market, even

in the 1650s. Such prints would be appreciated by most customers, regardless of their artistic knowledge or sensitivity.[55] The earliest surviving English print-seller's catalogue (Stent's of 1654) includes 'King Charles on Horsback', 'King Charles in a Laurel' and 'The late King since he was Crownd in Scotland' alongside portraits of Cromwell, Fairfax and Essex.[56] The absence of pictorial records of the Civil War and following events from Stent's stock might be explained by a basic English indifference to the visual image combined with a fear of government censorship.[57] No such records were published in London, and none appears to have been made there; until the Restoration views of the King's execution were engraved, printed and published on the Continent (see fig. 36).

Prints are occasionally inscribed as having been published with the privilege, i.e. permission, of the King (see figs 15, 31, 32); this privilege served as a mark of royal approval, but was also intended to protect the image from unauthorised reproduction. Privileges were initially confined to book publishing but Netherlandish print-publishers began to use them for prints from the late sixteenth century. The privileges noted on Crispijn van den Queboorn's engraving, issued by Hondius in 1626 (fig. 6), and on Delff's engraving of Mytens's portrait of the King issued in 1628 (fig. 32) relate to the general privileges issued by the States General to cover the entire engraved output of Hendrick Hondius and of Willem Jacobsz. Delff, in 1599 and 1622 respectively; the latter print also bears the privilege of Charles I. Other prints in this exhibition bear privileges from the King of France (nos 36, 51, 52), and the Holy Roman Emperor (nos 72–3).[58]

The privileges granted by Charles I may also indicate the importance that he attached to prints. This is suggested by the fact that in 1630 Mytens was paid £5 for 'perusing two pictures of ye King and Queene in black and white, to be cut out in brasse'.[59] The royal inventories include prints of 'The Kinge and Queene together' (presumably Van Voerst's engraving, fig. 16) and

'ye Soveraigne shipp'[60] as well as four copper plates, two engraved by Vorsterman and two by Van Voerst; although these reproduced works in the King's collection, none of them bore his own portrait.[61] It would be interesting to know what arrangements preceded both the engraving and the printing of these plates and whether commercial print-sellers were involved in their production.

Print-making in England in the first half of the seventeenth century was intimately connected with the much more sophisticated engraving industry in the Netherlands. Renold Elstrack, the most successful native-born engraver in the early part of the period, was only a second-generation Englishman. Native print-makers worked alongside foreigners such as Simon and Willem de Passe, Lucas Vorsterman, Robert van Voerst or Wenceslaus Hollar, while engravers such as Willem Delff and Jonas Suyderhoff produced high-quality printed portraits of the King without crossing the North Sea. This was also the case for the Continental engravers of broadsheets produced in the Commonwealth period.

The majority of these prints were based on existing likenesses, although we are rarely informed of the artist's name. However, the engraving by Willem de Passe of James I and Charles (as Prince of Wales) is inscribed *Wilh. Passaeus figu. et sculpsit* 1621, by which we may infer that the King (and Prince) granted the engraver a sitting.[62] The portrait of the Prince in that print was updated by the addition of a beard for re-use in the family group engraved by Willem de Passe c.1623 (fig. 24).

The first known printed portraits of Charles I were issued in 1613, and may depend on an anonymous painting at St John's College, Cambridge. One of these prints appeared in a book published by Crispijn de Passe and is almost certainly the work of his son, Simon;[63] it dates from three years before Simon settled in England and would have been produced in Holland. No. 27 (fig. 2) is a variant of that image. However, the first portrait to be engraved on the copper plate later used for no. 27 depicted Prince Henry (no. 28). That print was signed

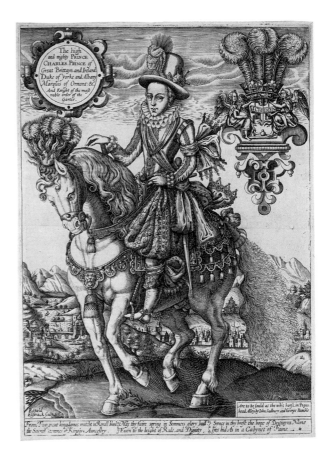

Fig 25 Renold Elstrack, *Charles I when Duke of York, on horseback*, c.1614 (no. 30)

by the little-known engraver Cornelis Boel, who was in England (at the royal palace at Richmond) in 1611. Following Prince Henry's death in 1612 both his portrait and Boel's name were burnished from the plate, which was re-engraved with the portrait of Prince Charles. The engraver responsible for Prince Charles's portrait is not known but he was probably associated with the De Passe workshop. Two prints by Elstrack (fig. 25 and no. 29), placing the Prince's likeness in an ornate setting, were produced c.1614. The equestrian portrait was published by the firm of Sudbury and Humble, the leading London print-seller in the early years of James I's reign; it was updated at least three times in the following years.

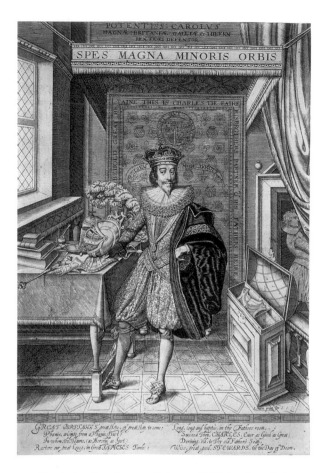

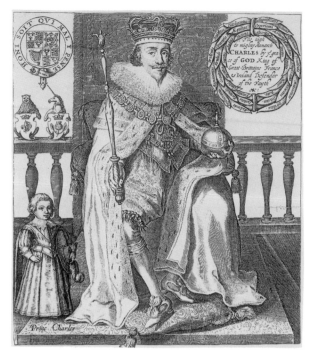

LEFT: **Fig. 26** William Hole, *Charles I with armour*, ?1625 (no. 41)
ABOVE: **Fig. 27** Willem de Passe and unknown engraver,
Charles I seated, with Prince Charles, c.1631/2 (no. 43)

Charles's elevation as Prince of Wales in 1616 was marked by the publication of a number of new engraved likenesses, initially by Simon de Passe (fig. 3), but soon copied by others including another Netherlander, Francis Delaram (no. 34). As we have seen, the Prince's features were updated in De Passe's printed portraits; in 1622 a fresh plate was produced and at the same time a companion portrait of the Prince's intended bride, the Spanish Infanta, was engraved by De Passe. Other prints relating to the abortive Spanish marriage plan are of poor quality (nos 37, 38), as is the Henrietta Maria betrothal print, issued in France (no. 39). An English print of the betrothal, issued shortly before James I's death, may be the work of Elstrack (fig. 5).

Throughout Charles I's reign prints were produced showing the King standing, seated or on horseback, with

his head and face occupying a relatively unimportant place in the whole. The interior with the King's armour (fig. 26) must originally have been issued before the death of the engraver William Hole in 1624. A little later Willem de Passe showed the King seated in majesty (no. 42); the plate was reissued after the birth of Prince Charles in 1630 (fig. 27). When the commanding figure of the King on horseback, with the City of London in the background, was published in 1626, it was a re-use of an anonymous portrait of James I of 1621 (nos 44, 45). After the birth of the King's first few children, native print-makers such as George Glover issued engravings for the popular market (fig. 29). In addition, French engravers produced a number of decorative portraits of their Princess, Henrietta Maria, and of her husband Charles I in which the portrait likenesses are general rather than specific (e.g. nos 51–3).

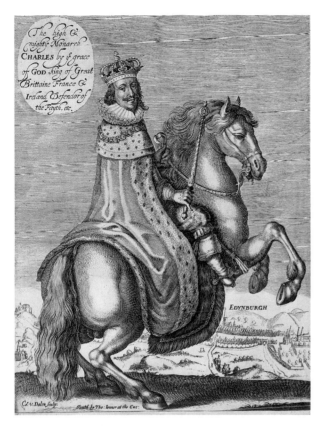

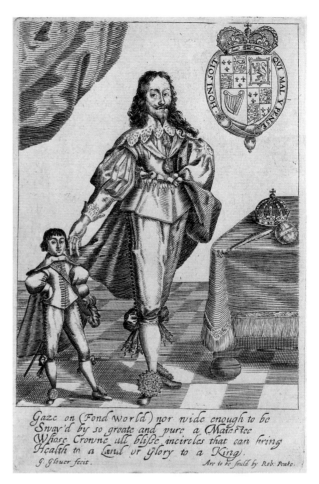

ABOVE: **Fig. 28** Cornelis I van Dalen, *'The high & mighty Monarch Charles'*, probably 1633 (no. 54)

RIGHT: **Fig. 29** George Glover, *Charles I and Charles, Prince of Wales*, c.1635/6 (no. 57)

There was evidently a market for such prints, but a shortage of accessible images to copy.

Mytens may himself have been responsible for ensuring that his portraits of Charles I were engraved by the painter's fellow countrymen rather than by Englishmen. The most notable of these engravers was Delff, whose portrait of the King in 1628 (fig. 32) was published in Holland. The quality of Delff's work is particularly noticeable when compared with the print by Crispijn van den Queboorn, possibly after another portrait by Mytens, issued two years earlier (fig. 6).

Although Charles I is chiefly known today through his painted portraits by Van Dyck, in the King's life-time these were accessible to only the most important members of British society. Van Dyck, who was well aware of the advantages of producing engraved images of paintings, does not appear to have had any of his English portraits engraved. However, before the start of the Civil War two of his portraits of the King were made available through printed reproductions; as soon as the genie was out of the bottle, large numbers of further reproductions were made and thus the images became both more widely known, and considerably debased. The first such printed copy – Robert van Voerst's 1634 engraving of the double portrait (fig. 16) – was the lineal ancestor of many later prints. The second printed reproduction was Hollar's etching (fig. 31) of the armed portrait of the King; Hollar's print appears

25

to have been behind the frontal image so frequently used in enamel memorial portraits (e.g. pls 7:20, 8:137). In each case it was Van Dyck's record of the King's face that was most valued, with other features of the head and shoulders. The rest of the figure and the architectural or landscape background in Van Dyck's paintings were rarely depicted until the development of mezzotint engraving from the 1660s.

The engraver of the first of these portraits, Robert van Voerst, arrived in London from Utrecht in 1627. Unlike the De Passe family, with whom he had trained, Van Voerst held an official position as 'Graver in Copper unto his Matie', for at an unknown date after his death in 1636 'Mr Faythorne' received a warrant of appointment in his place.[64] Van Voerst's appointment probably dates from the early 1630s: in 1631 he made reproductive engravings for the King of Titian's portrait of Emperor Otho then in the Royal Collection, and of Van Honthorst's portrait of Elizabeth of Bohemia; the copper

plates of both belonged to the King. Van Voerst was engaged to produce nine plates for Van Dyck's *Iconography* from 1634, the date of issue of no. 56 (fig. 16) which 'has a claim to be the finest engraving made in England in the seventeenth century'.[65] Had it not been for the plague that killed Van Voerst in London in October 1636, leaving his print of Bernini's bust of the King incomplete (fig. 42[66]), Charles I's other portraits by Van Dyck might well have been better known.

The second artist involved in these printed copies was Wenceslaus Hollar, who was brought to England by

BELOW LEFT: **Fig. 30** Wenceslaus Hollar, *'The Portraiture of the Mighty Monarch Charles'*, 1639 (no. 63 detail)
BELOW: **Fig. 31** Wenceslaus Hollar, *Charles I and the camps of his army in the march to Scotland*, 1639 (no. 65 detail)
RIGHT: **Fig. 32** Willem Jacobsz. Delff after Mytens, *Charles I*, 1628 (no. 48)

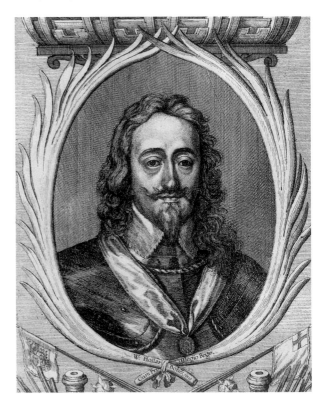

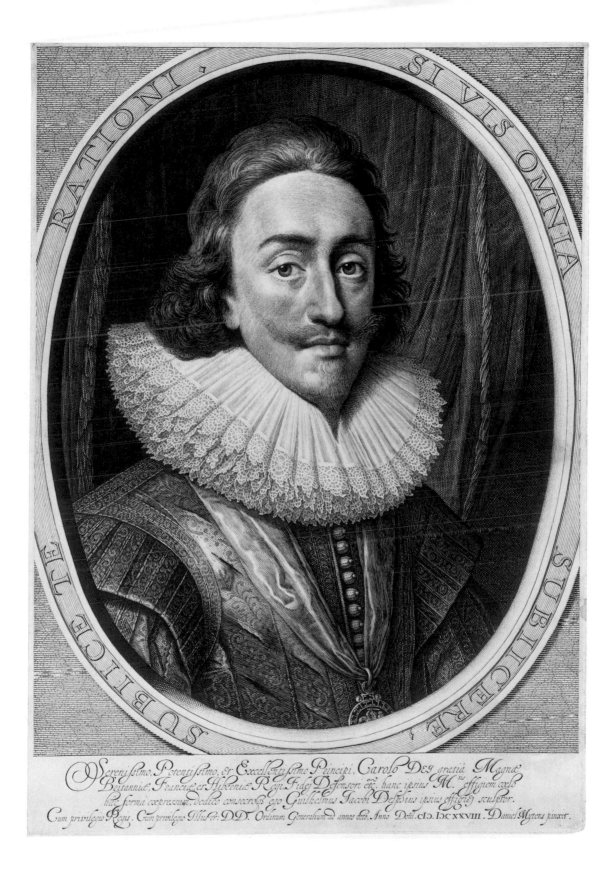

RATIONI · SI VIS OMNIA SUBIICE · TE · SUBIICERE

Serenissimo, Potentissimo, et Excellentissimo Principi, Carolo Dei gratiâ Magnæ
Britanniæ, Franciæ, et Hiberniæ Regi, Fidei Defensori etc. hanc ipsius Mtis effigiem cœlo
hâc formâ exprecerem, dedico consecroq; ego Guilhelmus Iacobi Delphius ipsius effigiei sculptor.
Cum privilegio Regis. Cum privilegio Illuftr. DD. Ordinum Generalium ad annos etc. Anno Dñi. clɔ lɔc xxviii. Daniel Mytens pinxit.

Lord Arundel in December 1636, two months after Van Voerst's death. However, the quality of Hollar's reproductive etchings after Van Dyck never reached the standard set by the engravings by the older artist; Hollar's chief importance for our subject was the quantity of prints that he produced, which thus made the King's portrait available, at limited cost, to a vastly increased market. In Hollar's other broadsheet of 1639 (see fig. 30), the King's head is also derived from Van Dyck's double portrait, possibly via the intermediary of Van Voerst's print (fig. 15). The latter was almost certainly the ultimate model for the etched pair of oval portraits issued by Hollar in 1641 (including fig. 8), the King's head in the etching of 1647 (see no. 76 and fig. 33), and the memorial etching of 1649 (fig. 9). Although no. 65 was published with royal permission, there is no evidence that the King followed Arundel's lead by employing Hollar to reproduce his paintings.

Another print-maker who was closely involved with Arundel was Rubens's former engraver, Lucas Vorsterman, who was granted sittings with Charles. His drawing of 1623 (British Museum) and his etching of c.1629 (no. 50) provide terminal dates for his residence in England and suggest a close relationship with the King, for whom Vorsterman engraved two reproductive plates.

After Van Dyck's death in 1641 several other reproductive prints were published of his portraits of the King; however, the way in which the original paintings were copied is seldom clear. In the early 1640s Jonas Suyderhoff issued a large printed portrait of the King (no. 71) based on his head in the 'Great Piece' which then hung in Whitehall Palace (fig. 17); but the print bears an Imperial privilege, suggesting that it may copy a version of Van Dyck's picture in a Continental collection. The miscellaneous posthumous additions to Van Dyck's *Iconography* include an anonymous print (no. 73) that reproduces a portrait of Charles I in armour.

The above summary suggests that in Charles I's lifetime the King's image was publicised by the distribution of prints, only a few of which bore the imprimatur or

King CHARLES his Royall welcom, at his happy and gracious return towards his Parliament, Who came on Munday Feb. 15. to Holmby in Northamptonshire in Peace.. To the great joy and comfort of all true hearted Subjects.

London, Printed for G. R. 1647.

Fig. 33 Unknown woodcutter, *Charles I*, 1647 (no. 77)

permission of the King. On the other hand the King's sculpted portraits were displayed in public places around the country in what has been described as a royal propaganda exercise.[67] As such, the influence of earlier French examples may have been relevant. For instance, the Queen's father, Henri IV, commissioned a life-size bronze equestrian figure of himself from Giambologna for the western end of the Ile de la Cité in Paris. His example probably lay behind Parliament's abortive scheme, debated in 1621, to commemorate James I and Prince Charles in two great double statues (one showing the two

figures robed, the other the two figures on horse-back) in Westminster.[68]

Pietro Tacca, who had completed Giambologna's work in Paris, refused an invitation to visit England.[69] However, Hubert Le Sueur was successfully lured to London in 1625, the year of Charles I's accession. By mid-1629 he signed himself 'sculpteur du Roy' and in Warin's medallion portrait of 1635 he is 'Duorum Regum Sculptor'.[70] Le Sueur's earlier work as 'Sculpteur Ordinaire du Roi' to Henri IV had included the manufacture of large- and small-scale portrait sculpture, and thus ideally equipped him to supply the many full-size statues and bust portraits of Charles I which were erected around the country during the fol-lowing years. Charles was the first British monarch whose sculpted likeness could be found in public places. Like those in France, these portraits were intended to impress upon his subjects both the power and the omnipresence of their monarch. A bust of the King by Le Sueur was set up in a niche in the wall of the Square Tower at the end of Portsmouth High Street by the Military Governor (Lord Wimbledon) in 1635. Wimbledon was dismayed to learn that the bust had been obscured by inn signs erected by publicans in the High Street and wrote to the Mayor and Corporation to complain, and further to insist that in future officers and soldiers remove their hats when passing the portrait.[71]

Although Le Sueur signed himself 'Praxiteles Le Sueur' and was evidently a highly competent bronze worker, in quality his work was far from the standards achieved by both Giambologna and Tacca – let alone Praxiteles. Just as many of the oil paintings and minia-tures commissioned by Charles I were repetitive and/or derivative, so Le Sueur's portraits are based closely on the French types of Henri IV which had been established by Jacquet and Tremblay. His skill at bronze casting may have been Le Sueur's chief attraction to the King for one of his first royal commissions involved visiting Italy to take moulds from classical statuary, in order to make

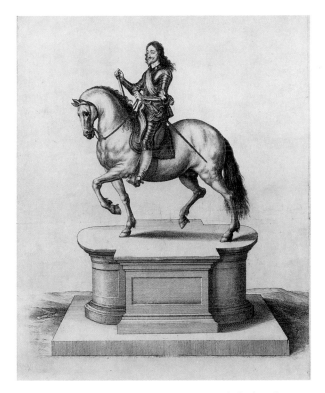

Fig. 34 Wenceslaus Hollar, *Equestrian statue of Charles I*, late 1630s (no. 59)

bronze reproductions for the royal gardens at St James's Palace.[72] The King's face in Le Sueur's bronze sculptures made its first appearance in his best-known work, the equestrian figure in Trafalgar Square and was repeated on countless occasions (fig. 39; see also figs 40, 41).[73]

This group, dated 1633, had been commissioned around three years earlier by the Lord Treasurer Sir Richard Weston for the garden of his house, Mortlake Park, Roehampton, and was only moved to its present position after the Restoration. Therefore it was origin-ally a far from public monument; between 1633 and 1674 it was known chiefly via Hollar's etching, which combines Van Dyck's with Le Sueur's image (fig. 34; compare fig. 20).[74] By 1639, the date of the last royal payment to Le Sueur, his rôle as sculptor to the English Crown was nearing its end; two years later he left London and returned to his native France.

Badges and Memorial Portraits

The execution of Charles I was quickly followed by the publication of a small volume entitled *Eikon Basilike. The Pourtraicture of his sacred Maiestie in his solitudes and sufferings*. The publisher, Richard Royston, was a devoted royalist and produced the first edition of his work in the first few days of February 1649. In the following month William Dugard produced a new edition with the King's prayers appended, and between June and December 1649 John Williams issued a series of miniature editions of the book (e.g. no. 107), which could be hidden more easily if necessary. Royston, Dugard and Williams were each arrested in the course of 1649 but the republican government could do little to curb the book's popularity. 'The appearance in one place, and within the space of one year, of some thirty-five editions of the same work (besides another twenty-five published in Ireland and abroad) was an event perhaps without a parallel'.[75]

The text was written in the first person, as if by the late King himself. After three centuries of discussion it appears that the King did indeed prepare most of the text; however, it was brought together as a book by Dr John Gauden (d. 1662), later Dean of Worcester. The frontispiece too was partly designed by the King; it was engraved by William Marshall and was soon copied by others, including Hollar (fig. 35). In this curious design, the symbolism of which was explained in the accompanying text, the King's earthly crown lies at his feet; he holds a crown of thorns (indicating his suffering) while gazing at a celestial crown; his strength amid turmoil is represented by the storm-beaten rock and weighted palm-tree. The image was particularly potent and was the first of many to depict Charles I as martyr.[76]

Part of the power of Marshall's image emanates from the pure profile portrait of the King. Profiles are rarely found in either painted or engraved portraiture but are the norm for coinage and for most medals. It is implausible to suggest that the profile head in Van Dyck's triple portrait (pl. 5) inspired the *Eikon Basilike* image because the painting was in Rome from 1635 until the early nineteenth century. Although the new image is close to the 1639 Dominion of the Sea medal (pl. 8:124), a connection with the profile portraits on royalist badges produced by Thomas Rawlins from the early 1640s (e.g. pl. 8:129) is also suggested.[77]

These pieces were produced in large quantities for the King's supporters; they also served as a mark of loyalty to the royalist cause in the years between 1649 and 1660, and ensured that the image of the late King was kept alive in the minds and hearts of the people. Military rewards are a slightly separate type of object to royalist badges. After the Battle of Edgehill, Rawlins was commissioned to make 'a medal in gold for our trusty and well-beloved Sir Robert Welch, knight, with our own figure and that of our dearest sone Charles; and on the reverse thereof to insculpt ye form of our Royal Banner'.[78] Another military reward, the so-called 'Forlorn Hope' medal, was made by Rawlins in 1643 with instructions from the King that it was 'to be worn on the breast of every man, who shall be certified under the hands of their Commanders-in-Chief, to have done us faithful service in a forlorn hope'.[79] It was further specified that 'no soldier at any time doe sell nor any of our subjects presume to buy or wear any of these said badges other than they to whom we shall give the same'. Rewards were also distributed by the Parliamentarians: following the Battle of Edgehill, both armies distributed medallions to their followers, using almost identical designs and merely adjusting the facial features of Charles I to depict their own leaders.

Badges had a more general function than rewards and the manner in which they were circulated and worn is not so well documented. One was worn by Captain John Smith, a royalist leader, when he fell at Cheriton-Fight in March 1644. In the same year the Parliamentary commander, Sir Thomas Fairfax, is known to have pulled the badge from his hat at the Battle of Marston Moor, in order to pass unassailed through the enemy lines.[80]

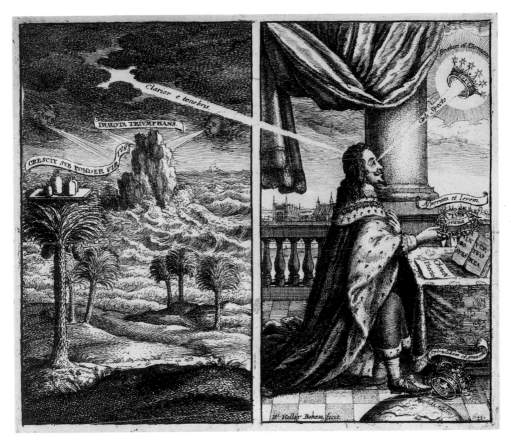

Fig. 35 Wenceslaus Hollar after William Marshall, *Frontispiece to the Eikon Basilike*, 1649 (no. 80)

Rawlins, described by John Evelyn as 'an excellent artist, but a debased fellow', appears to have trained under Nicolas Briot and to have come to the fore following the transfer of the Royal Mint from London to Oxford. The royal warrant for his appointment as Engraver to the Mint in 1643 describes him as 'our Graver of our Seals, Stamps, Medals'. In 1647, the year after Briot's death, Rawlins became Chief Engraver of the Mint, but he appears to have spent much of the following five years in France. He was also active as a gem engraver and produced cameo portraits and ringstones bearing the King's image both before and after the King's execution.[81] Rawlins returned to his post as Chief Engraver after the Restoration and continued to serve in this capacity until his death in 1670. The badges that were produced by Rawlins and his associates were probably chiefly made in the first half of the 1640s. It would seem reasonable to

suggest that the smaller badges, made of base metals, were produced closer to the time of the King's execution than the gold and silver ones. Curiously, the portraits on these pieces (e.g. pl. 8:131–3) are closer to the 'Juxon medal' type than to Rawlins's larger badges.

In contrast to Rawlins's royalist medals, the memorial enamels and rings bearing the King's image are rarely of a high quality. There are documented instances of the distribution of such pieces: on her return from France in 1642, Henrietta Maria rewarded those who had lent money to the royalist cause with rings, lockets and slides bearing the royal cipher and portrait; the intention was that these tokens would be exchanged for honours or repayment once the troubles were over.[82] Many of the

31

surviving rings bear the King's portrait, crudely painted in enamel, with an inscription (frequently 'Remember' or 'Prepared be to follow me') on the inside of the hoop.[83] Such a ring, apparently presented by the King himself, was worn by Sir Edmund Verney when he died clutching the King's standard at the Battle of Edgehill in 1642.[84] A skull on the reverse of a ring (as in no. 138) indicates that it was produced after the King's death. No. 137 consists of a small inscribed gold box containing a memorial ring re-formed as a fob ornament (pl. 8:137). The King's image is a much-debased version of Van Dyck's frontal portrait, first reproduced by Hollar in 1639 (fig. 31).

Memorial rings were also made in gold and silver: in August 1651 a goldsmith in the City of London, Samuel Hopton, was found to have a stock of rings 'with the late King's pictures', made of sub-standard gold.[85] Portraits of the King were produced on a wide range of materials. George Vertue described one carved on a peach stone by an artist subsequently identified as Nicholas Burgh, Poor Knight of Windsor. The rough sketch that Vertue made of Burgh's portrait suggests that it used the same frontal pose as was adopted in the enamel memorial rings.[86]

Just as these badges and rings concentrated on the head and face of the King, so London print-sellers such as Peter Stent continued to sell their stock of portraits of Charles I.[87] In the troubled times of the late 1640s few skilled engravers remained active in England. A number of those involved in print production (including the print-seller Robert Peake and the engraver William Faithorne the Elder – who were both imprisoned at the Siege of Basing House in 1645 – and Wenceslaus Hollar) actually fought for the King, but they left England in the mid- or late 1640s. It was therefore on the Continent, and particularly in the Netherlands – the place of birth of many of the best print-makers – that new prints, showing the narrative of the King's life and death, were produced. The vast collection of broadsheets made by George Thomason before his death in 1666 includes a tiny

proportion of illustrated sheets, and these few appear to be mostly of Continental origin.[88] The production of fine engravings and etchings depicting the events of the 1640s and 1650s appears to have been the exclusive activity of royalist supporters – many of whom found temporary exile in the Netherlands. Cromwell's supporters instead caricatured the late King – and other royalists – by showing him in their Puritan tracts with long flowing locks; these prints were countered by royalist prints showing Cromwell as the Anti-Christ.

Religion played a crucial part in Charles I's downfall and the cult of the Martyr King that arose soon after his death was based on the belief that he died a martyr for the Anglican church. While the iconographic parallels between religious imagery and the portraiture of Charles I that have been noted for paintings produced during the King's lifetime[89] may occasionally be no more than accidental, elements in the depictions of his execution are surely more deliberately taken from religious imagery. In the lower scene of fig. 36 we find a fainting woman reminiscent of earlier depictions of the Virgin at the foot of the cross; in the smaller fields at either side are other figure groups that deliberately recall scenes from Christ's Passion. William Marshall's frontispiece for the *Eikon Basilike* (see fig. 35) had also employed elements found in depictions of Christ's Agony in the Garden. In another early Continental broadsheet (no. 84) figures are shown viewing the King's corpse and paying money for associated relics; there was an instant demand for such relics as miracles 'wrought by his blood' were reported.[90]

Printed depictions of the King's execution were evidently extremely popular and were repeated many times, with differing accompanying text. Apart from an illustration in a book entitled *Theatrum Tragicum*, published in Amsterdam in 1649, few certain dates can be assigned to these prints.[91] In the aftermath of the execution it was considered a 'capitall crime for any to speake, preach, or write against the present proceedings'.[92] However, by the mid-1650s the scene in front of the

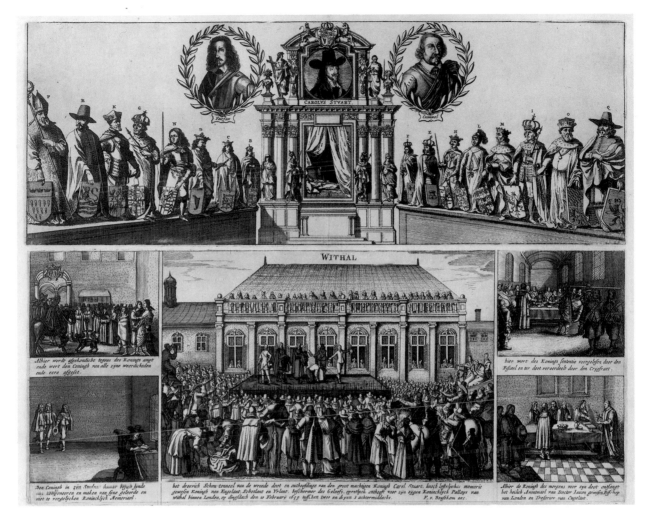

Fig. 36 Anonymous, *The execution of Charles I, with other scenes*, c.1650 (no. 85)

Banqueting House, Whitehall, was sufficiently well known to be summarised in illustrations to Anglican prayer books, where – for the next two hundred years or so – the worshipper was reminded of the Martyr King through depictions of him on the scaffold, opposite the readings for 30 January.[93] It is in this context that the large picture now in the Scottish National Portrait Gallery was produced: an anonymous work, probably of the early 1650s, painted on the Continent on the basis of contemporary engravings.[94]

After 1660, particularly at the time of the trials of the regicides, portraits of Charles I and depictions of his execution were made and marketed with renewed energy. Engravers and print-sellers seldom allowed personal political affiliations to control their activities. Thus Peter Lombart's 'headless horseman' print, first engraved in the early 1650s with Charles I's horse (after Van Dyck: see fig. 14) and an unknown rider, was used as the framework for portraits of both Oliver Cromwell and Louis XIV before being engraved with Charles I's head in the 1660s (figs 37, 38).[95] New editions of the *Eikon Basilike* were published in 1662, 1681, 1685 and 1687[96] and mezzotint versions of Bower's portrait were

33

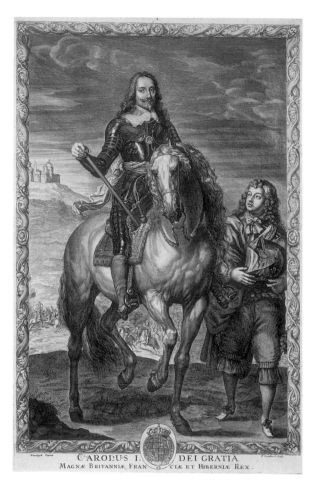

OLIVERIVS MAGNÆ BRITANNIÆ. HIBERNIÆ. ET TOTIVS ANGLICI IMPERII PROTECTOR. HANC SVMMI ET TOTO TERRARVM ORBE CELEBERRIMI HEROIS EFFICIEM SVPREMO SVÆ CELSITVDINIS CONSILIO D.D.D.

CAROLVS I. DEI GRATIA MAGNÆ BRITANNIÆ, FRAN CIÆ ET HIBERNIÆ REX.

engraved by John Faber I in *c.*1713.[97] Mezzotint versions of the *Eikon Basilike* portrait were engraved by John Smith at about the same time,[98] while images of Charles I as martyr were engraved by William Faithorne II in *c.*1690 (fig. 10) and by John Faber II in 1717.[99] This is the context in which nos 91–6 and 101–2 were created, only one of which is dated (no. 101 of 1717).[100] By that time Van Dyck's portraits of the King were becoming better known through both engraved

ABOVE LEFT: **Fig. 37** Peter Lombart, *Oliver Cromwell on horseback*, 1660s (no. 97)

ABOVE: **Fig. 38** Peter Lombart, *Charles I on horseback*, 1660s (no. 98)

and painted copies. The compositions of his memorable images of Charles I were thus publicised for the first time as a prelude to the photographic reproductions that are so widely available today.

NOTES

1 For Charles I's collection, and in particular the works acquired from Madrid in 1623 and Mantua in 1628, see Millar, 1958–60 and 1970–2, and MacGregor, 1989 and Introductions to OM and CW.

2 For Charles I's reign see in particular Sharpe, 1992; also Howarth, 1997.

3 *Calendar of State Papers Venetian, 1610–13*, no. 817.

4 D'Israeli, 1830, III, p. 113.

5 For his clothing see Cumming, 1989.

6 See OM, p. 15, for extract from Haydock's translation (1598) to Lomazzo's *Trattato* (1584). For a summary of Charles I's portraiture see Piper, 1949.

7 Quoted in OM 146.

8 Cumming, 1989, p. 343.

9 *Vertue Notebooks*, IV, p. 193.

10 *Vertue Notebooks*, II, p. 98.

11 Charles I was *tanto amico e rimuneratore di' peregrini ingegni* (such a friend and employer of ingenious foreign [artists]; OM, p. 20).

12 For Peake's 1613 portrait of Prince Charles in Cambridge, see *Dynasties*, 1995, no. 128.

13 Early inventories of the Royal Collection include a 'gold case', containing miniature portraits by Isaac Oliver of Prince Henry on one side and Prince Charles on the other (see, e.g., *Vertue Notebooks*, IV, p. 93).

14 PRO AOI 390/54 (1616–17).

15 It is possibly identifiable with the portrait on loan to Montacute House (NPG 1112).

16 OM, pp. 15–16, 84.

17 OM, p. 15. See also Ter Kuile, 1969.

18 For Honthorst see CW 74 and NPG 4444 (half-length portrait of Charles I, 1628).

19 Stephen Orgel in *Inigo Jones*, 1973, p.165.

20 Repr. OM, fig. VIII.

21 Millar, 1958–60, p. 180.

22 OM, p. 90.

23 See CW 152.

24 OM 120.

25 The original appearance of the double portrait may be guessed at from the version at Welbeck (repr. OM, fig. 12).

26 See Millar, 1982 and Carpenter, 1844. According to the latter, Van Dyck's initial charge was £20 for a half-length, £25 for a whole-length; by 1638 his charges had increased to £30 and £50 respectively, but were reduced by the King to £26 and £40 (Carpenter, 1844, p. 66). These charges should be compared with the payments made in the previous decades for key portraits of the Duke of Buckingham: £120 in 1623 to Mytens and £500 in 1625 to Rubens. Van Dyck's 'Great Piece' cost the King £100 in 1632 (Carpenter, 1844, p. 71).

27 The grant is transcribed in Carpenter, 1844, p. 65.

28 From J.P. de la Serre's account of the visit, published in 1639 (no. 104 in this exhibition); translation from Millar, 1982,

29 See Strong, 1972.

30 The similarity of angles used in Van Dyck's portraits might suggest re-use (compare, for instance, figs 17 and 19, and possibly also fig. 18). On this point see *Vertue Notebooks*, II, p. 88.

31 For these see OM, fig. 16 (collection of HRH The Duke of Kent) and Brown, 1991, no. 69 (Rijksprentenkabinet, Rijksmuseum, Amsterdam 1887. A1162)

32 Several repetitions are included in Van Dyck's 'Memoire' (see Carpenter, 1844, p. 67). An indication of the number of copies in circulation in England in the early eighteenth century is given in *Vertue's Notebooks*.

33 See Lightbown, 1989 (2), pp. 239–40 and *Vertue Notebooks*, IV, p. 160, concerning 'two curious silver embossd oval plates chasd.' of the King and Queen after Van Dyck, inscribed on the back CV. Londinum'.

34 Wood, 1998, pp. 126–8.

35 *Samuel Cooper*, 1974, no. 144.

36 The composite sheet of portraits of Charles I's family in the Dutch Royal Collection (inv. no. m 483) may have been made, by a member of Hoskins' studio, for presentation to Princess Mary at the time of her marriage to Prince William in 1641. The portraits are chiefly based on works by Van Dyck.

37 For Petitot see Lightbown, 1970 and Lightbown, 1989 (1), pp. 68–9.

38 For instance, one at Kingston Lacy (National Trust).

39 See Millar, 1970–2.

40 See *MI*, pls XIX–XXXIV.

41 Howarth, 1997, pp. 107, 115–16.

42 Briot's commission for the 1626 coronation medal referred to 'certain pieces of largesse of gold and silver in memory of his Majesty's coronation'.

43 Information from Luke Syson, Department of Coins and Medals, British Museum.

44 In his note of the contents of the drawers in the Whitehall Cabinet Room, Van der Doort lists two pieces that are almost certainly identifiable with the 1630 and 1639 Dominion of the Sea medals (Millar, 1958–60, p. 139).

45 One of the Scottish Coronation medals, the edges 'much worne in yor Mats pockett', was noted by Van der Doort among the King's collection of coins and medals (Millar, 1958–60, p. 130).

46 Van Dyck's painting was copied in Rome by J. M. Wright in the 1650s; Briot may have had access to an earlier copy.

47 See Allen, 1941; also Schneider, 1956.

48 For instance, the medallion portraits of the Earl of Leicester (by Goltzius; *MI*, pl. IX/12) and of the Earl of Cumberland (by Jacques II de Gheyn), made in 1586 and 1594 respectively.

49 The monopoly was issued in view of his 'extraordinary Art and Skill in Drawing Graving and Imprinting of Pictures ... of us and others' (Auerbach, 1961, p. 40).

50 Griffiths, 1998, p. 56.

51 See especially Jones, 1983, who considered that the lines are too soft and rounded to have been made with a burin and that they must instead have been cast.

52 See Farquhar, 1916 and MacGregor, 1989, p. 410.

53 In the sets of counters the monarchs were supplemented by other members of the Stuart line: Mary Queen of Scots and Lord Darnley; Princess Elizabeth and Frederick V of Bohemia, together with Frederick's successor Charles Louis; and the infant Prince Charles (later Charles II). The original series of the *Baziliologia* terminated with Henry VIII, but later additions (including De Passe's portrait of Prince Charles, nos 31–3) brought the series up to date.

54 Griffiths, 1998, p. 96. Griffiths' study has added considerably to our knowledge of the seventeenth-century English print; see also Martin, 1987.

55 Griffiths, 1998, pp. 20–1.

56 Globe, repr. p. vi.

57 See Williams, 1990.

58 On privileges see Griffiths, 1998, p. 15, where the role played by the Stationers Company is also examined.

59 See Stopes, 1910, p. 162. This reference cannot easily be related to surviving engravings.

60 Presumably John Payne's magnificent print (Griffiths, 1998, no. 58).

61 Millar, 1958–60, pp. 176, 148; Millar, 1970–2, p. 304.

62 Hind, II, p. 291, no. 10; see Griffiths, 1998, no. 22. This print is not recorded in the Royal Collection.

63 Hind, II, p. 54, no. 4; RCIN 601491.

64 PRO LC 3/33. I am indebted to Dr Kate Gibson for this reference.

65 Griffiths, 1998, p. 71.

66 Griffiths, 1998, no. 43.

67 Howarth, 1989 and 1997.

68 Howarth, 1997, p. 35.

69 However, a small bronze attributed to Tacca, formerly at Upton House, suggests that the project was at least begun (info. A. Laing).

70 For Le Sueur see especially Avery, 1982.

71 Howarth, 1997, p. 180.

72 Five of these survive at Windsor Castle.

73 See below, pp. 36–8.

74 Charles owned a reduction of the equestrian group (Millar, 1958–60, p. 95); this may have been the bronze at Ickworth (Avery, 1979, figs 14–16). The statuette today in the Royal Collection (RCIN 29930) is not wholly contemporary.

75 Madan, pp. 2, 164–5. Thomason records receiving a copy on 9 February (see Fortescue, 1908). On 21 February Dr Denton wrote to inform Sir Ralph Verney in Paris that he hoped to forward

a copy of 'the King's booke' to him soon: 'It hath beene hitherto at 8s and 10s price ... It hath beene much suppressed, the first printer and impression plundered and presses broken' (Verney, 1892, II, p. 402).

76 The burden of the argument contained in the *Eikon Basilike* had been foreshadowed by works such as Edward Symmons, *A Vindication of King Charles: or, a loyal subjects duty ... A true parallel betwixt the sufferings of our saviour and our sovereign*, issued in 1648 but partly complete as early as May 1646 (no. 105). Many sermons were preached on the subject of Charles I as martyr (e.g. Fortescue, 1908, II, p. 316).

77 See Farquhar, 1906.

78 See also *Vertue Notebooks*, IV, p. 36. The medal is *MI*, pl. XXV/5.

79 *MI*, pl. XXVI/8.

80 Farquhar, 1906, p. 5.

81 Scarisbrick, 1994, p. 179.

82 Scarisbrick, 1994, p. 188.

83 For a selection see Oman, 1974, pls 79, 80.

84 Verney, 1892, II, p. 116.

85 Oman, 1974, p. 66.

86 *Vertue Notebooks*, II, p. 38. On Burgh see Fellowes, 1944, pp. xlii, 35; his will is among the Archives of St George's Chapel, Windsor (XIII.B.2, p. 33).

87 See Globe, *passim*.

88 For this collection see Fortescue, 1908. Although engravings relating to the King's death appeared in March and April 1649 (Fortescue, 1908, I, pp. 730, 738), the first record of the oft-repeated execution scene (compare fig 36) is the illustration in *Theatrum Tragicum*, published in Amsterdam and received by Thomason in May 1649 (ibid., I, p. 741). Sebastien Furck's related broadsheet, published in Frankfurt, is listed by Thomason under 1650 (ibid., I, pp 822–3).

89 See especially Howarth, 1997.

90 Beddard, 1984, p. 37.

91 See Williams 1990 and Berghaus, 1989.

92 Letter from Dr Denton in England to Sir Ralph Verney in France, 21 February 1649 (Verney, 1892, II, p. 402).

93 The type is similar to nos 92, 93 in this exhibition.

94 I am grateful to the Scottish National Portrait Gallery for granting me access to the file assembled by Helen Smailes on this painting.

95 See Layard, 1922.

96 Madan, nos 65–8.

97 CS 24–6.

98 CS 44, 45.

99 CS 74.

100 See Martin, 1987.

Portrait Busts

The portrait bust was virtually unknown in Britain before the reign of Charles I. The three busts included in this exhibition correspond with three aspects of his iconography represented by the paintings, miniatures and prints. The first (fig. 40), a version of the bronze by Hubert Le Sueur presented to Oxford University by Archbishop Laud in 1636 (fig. 41), may be compared with the work of the early immigrant painters at Charles I's court, among whom Daniel Mytens was pre-eminent. The second, a marble ascribed to Francis Bird (fig. 43), stands here for the bust of the King by Bernini, completed in 1636 from Van Dyck's triple portrait (pl. 5) but destroyed in the Whitehall fire of 1698. The third bust (fig. 45), a painted plaster of unknown date and authorship, nonetheless includes some recollection of Van Dyck. It is probably one of the earliest of a third type of bust portrait, which continued to be made into the eighteenth and nineteenth centuries.

Since Mrs Arundell Esdaile first published a survey of portrait sculpture of Charles I in *The Burlington Magazine* in 1949,[1] Dr Charles Avery has largely reconstructed the shadowy career of Hubert Le Sueur (*c.* 1585–1670), the French royal sculptor who was brought to London in the retinue of Princess Henrietta Maria in 1625.[2]

Le Sueur executed as many as fifty commissions for Charles I.[3] In statues of the King (surviving at St John's Oxford and at Winchester Cathedral) he treats armour as if it were stuffed skin, curving to the form of the body without suggesting either the shape of real armour or the human frame beneath. The bronze busts, which Avery classified into four types,[4] all show the same frontality and 'iconic' quality. They depend to some extent on the first

portrait that Le Sueur made in bronze, the equestrian statue of 1630–3 commissioned by the Lord Treasurer, Sir Richard Weston (fig. 39), and the armour is always over-emphasised at the expense of the head. As Avery has observed, the subjects of Le Sueur's early portraiture in Paris and London were all deceased, and his failure to breathe life into the features of his English sovereign is perhaps the most serious of his weaknesses as an artist.

The Royal Collection bust portrays the King in armour with a Medusa mask and lion-mask pauldrons. These are rare even in the most lavish parade armours of the time, but common in mythological art, where Vulcan is invariably seen fashioning such armours. While it was normal for kings to be portrayed with these pauldrons

Fig. 39 Hubert Le Sueur, *Charles I on horseback*, bronze, 1630–3 (Trafalgar Square, London; detail)

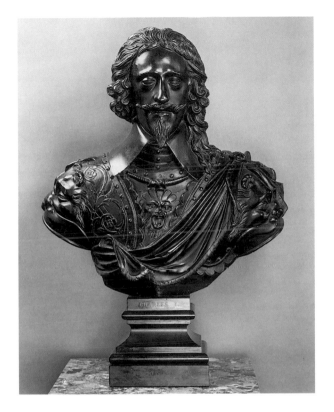

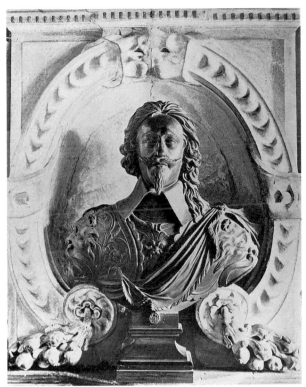

ABOVE: **Fig. 40** Hubert Le Sueur, *Charles I*, seventeenth century (no. 111)

ABOVE RIGHT: **Fig. 41** Hubert Le Sueur, *Charles I*, bronze, c.1636 (Bodleian Library, Oxford)

(for example, Tremblay's portrait bust of Henri IV or Dieussart's of Christian IV), Le Sueur did not reserve them for Charles I.[5] This bust is probably one of the earliest repetitions of a much-repeated model.[6] Its facture is identical with that of the Bodleian example but it is weaker in several details of the modelling. The rows of domed rivets along the edges of the shoulder pieces and gorget are not found on every example of the type. They are actual rivets, which have been tapped into square holes punched through the cold bronze, a technique whose use reminds us that Hubert's father, Pierre Le Sueur, was a master-armourer.[7] The Lesser George, which sometimes overlaps the truncation, has been snapped off at some point.

Most of Le Sueur's busts and statues were made for public and official places, and placed in purpose-designed niches (fig. 41),[8] while a smaller number (which, it must be remembered, includes the equestrian statue) were more private treasures.[9] Van der Doort records three busts and an equestrian statuette in the King's apartments at Whitehall in 1639,[10] but none can be identified in the sales of the King's Goods, and none has survived in the Royal Collection. No. 111 was bought by George IV in 1820 and placed in the Crimson Drawing Room at Carlton House.[11] It was transferred to Windsor in 1828,[12] together with bronzes of Charles V and Philip II of Spain and the Duke of Alva, and since 1830 it has stood in the Grand Reception Room with busts of Richelieu by Warin and Condé and Turenne after Derbais. By this time, Le Sueur's bust had become a collector's bronze, suitable for parade rooms and galleries, and to be placed alongside the heads of great men without respect either to its inferior quality or to the martyr's cult.

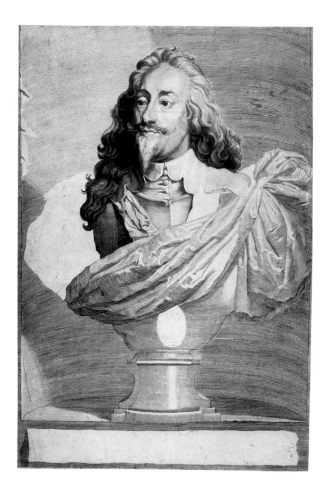

Fig. 42 Robert van Voerst, *Charles I*, engraving, 1636 (British Museum)

There is no record of a sitting for any of the busts or statues, and it is unlikely that Le Sueur, an image-maker rather than a portraitist, could have responded to working in such a way.[13] In the case of the second bust (fig. 43) the source of the likeness is equally elusive, though for quite different reasons. This impressive, though weathered, marble was published in 1908 by Lionel Cust as a copy of the famous bust by Bernini, carved in 1636 from Van Dyck's triple portrait (pl. 5).[14]

Bernini was granted permission by his employer Pope Urban VIII to execute Queen Henrietta Maria's commission for a marble bust of the King in 1635. Van Dyck's triple portrait was painted in the same year and was immediately sent to Rome; the bust arrived in England in July 1637.[15] It was sold from Greenwich by the Commissioners of the Late King's Goods in 1651, recovered in 1660, and last recorded in the inventory of Whitehall of 1688;[16] it was destroyed in the Whitehall Palace fire of 1698.

The baroque swagger of the Royal Collection bust, in which the King is presented with an air of lofty confidence unique in his portraiture, would seem to accord not only with Bernini's manner but also with his superior standing among seventeenth-century artists. However, in 1978 Michael Vickers proposed that it was a replica not of Bernini's bust but of another supposedly lost original, by François Dieussart.[17] Vickers argued cogently that while the Windsor bust bore no resemblance to Van Dyck's triple portrait (they are shown together in this exhibition for the first time), it recalled several known works by Dieussart, notably the bust of the King's nephew Prince Rupert of the Rhine of 1637 (Ashmolean Museum, Oxford). However, he advances no other evidence that such a bust of the King ever existed.

In 1996 Gudrun Raatschen published two plaster casts of the face of Bernini's bust (fig. 46), which have little or nothing in common with that of the Windsor marble.[18] A unique engraving (fig. 42) in the British Museum showing a bust identical with that at Windsor was published by Cust in 1908 as representing Bernini's original, but the engraver to whom it is confidently attributed, Robert van Voerst, died suddenly of the plague in London in October 1636, many months before the Bernini bust arrived, and before the engraving was finished. One possible explanation is that the engraving was made from a drawing of Bernini's bust made as soon as it was complete in around June 1636, and sent from Rome in advance of the bust, at some time just before Van Voerst's death. The engraving actually depicts a drawing of a bust in a niche, such that the edges of the sheet on which the drawing is made are represented in *trompe l'oeil* as torn.

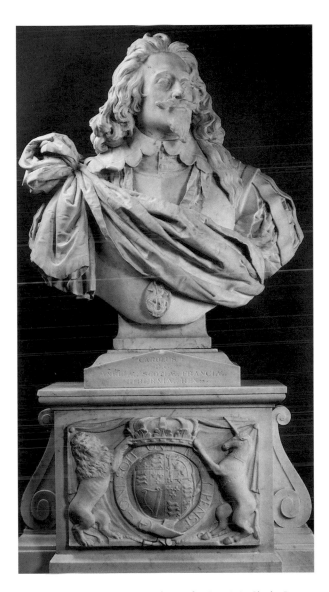

ABOVE: **Fig. 43** Unknown sculptor after Bernini, *Charles I*, *c*.1700 (no. 112)

ABOVE RIGHT: **Fig. 44** Attributed to Jan Blommendael, *William III, c*.1700 (RCIN 35857)

The Windsor marble and its companion, of William III (fig. 44), were purchased by HM Queen Elizabeth The Queen Mother in 1937 from the collection of Mr B.W. Currie of Minley Manor, Surrey.[19] Esdaile's attribution of the busts to Francis Bird (1667–1731) was based partly on the knowledge that he possessed a cast of the face of the Bernini. The two busts are plausibly of *c*.1700. As a copy, the *Charles I* offers little basis for attribution. It is hard to recognise as more than passing the similarities which Mrs Esdaile proposed between the *William III* and Francis Bird's work (such as the bust of the Earl of Godolphin in Westminster Abbey), and her subsequent re-attribution of both busts to Thomas Adye (fl 1730-53),[20] whose few surviving works date from the 1730s, now seems even less likely. The *William* is far

Fig. 45 Unknown sculptor, *Charles I*, perhaps late seventeenth century (no. 113)

closer in conception and certain details to the work of Dutch sculptors such as Jan Blommendael (*c.*1650–1703), who carved a similar bust of the Stadholder–King in 1699 (Mauritshuis, The Hague).

The grandeur of their presentation suggests that these two busts were commissioned by William III himself. Whether or not the *Charles I* represents the lost Bernini, William III must have counted the loss of that master-piece a great disaster, and may have sought to replace it with something equally impressive. If so, he took the opportunity to pair his own portrait with that of his (and his wife's) grandfather, thus reasserting the Restoration of the Stuart dynasty, just as in his state portrait by Kneller he mimics exactly the pose of Van Dyck's great portrait of Charles I (fig. 19).[21]

If there are few hard facts relating to the Windsor marble, the third bust exhibited here (fig. 45) presents an even greater mystery. It is of plaster, now painted to resemble bronze but with a terracotta finish when pur-chased by HM Queen Elizabeth The Queen Mother in 1947.[22] Recent analysis has shown that the first paint layer (beneath the terracotta colour) was a bronzed finish con-taining powdered brass.[23] This bust was placed by Mrs Esdaile in the category of 'synthetic' likenesses.[24] The armoured shoulders and breastplate are a poor conflation of motifs from Le Sueur's repertoire, but there is far greater quality to be found in the head, which in profile is perhaps the closest surviving sculptural rendering of the Van Dyck: the slight stoop which yet presents the face vertically, the pronounced lobes to the forehead, the details of moustache and beard, and even the wisps of hair that obtrude on to the temple and cheek, are all very Van Dyckian. (The sharp, thin nose is an obvious replacement, and the tips of the moustache have been damaged and partly replaced.)

This discrepancy in quality between the head and the rest of the bust recalls Vertue's description of 'another cast I have but differing in the hair and Shoulders which I take to be a cast of that very face of the Marble Bust [i.e. the Bernini], but alterd in some other parts by some skill-ful Artist'. However, so far as can be judged from its appearance in the background of a drawing of Vertue, his bust was not of this pattern.[25]

This elusive object seems to belong far closer to the King's lifetime than the well-known post-Restoration images, such as John Bushnell's statue for the Royal Exchange (plaster, Central Criminal Court, London), or the designs attributed to Gibbons for a statue of the late King in armour, at once ascending to heaven and crushing his former oppressors, which was proposed for Wren's unachieved expiatory chapel at Windsor. It has still less in common with Roubiliac's invention of 1759 (marble bust, Wallace Collection, London) and its variants.

Yet more imaginary busts by lesser sculptors appeared as the nineteenth-century romantics began to claim the

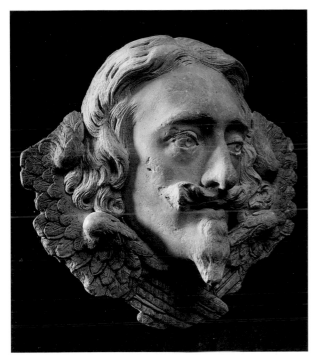

Fig. 46 Plaster cast of the face of Charles I, after Bernini (Berkeley Castle, Gloucestershire)

Martyr King, but it is interesting to see the survival of Le Sueur's image in such *mises en scène* as W.J. Bankes commissioned for Kingston Lacy in Dorset from Carlo Marochetti,[26] and the group of historical busts assembled at The Vyne in Hampshire in 1846 by W.L. Wiggett Chute. Here, as at Castle Howard in Yorkshire, the King was paired with Cromwell (in a version of Edward Pierce's bust).[27]

Still later in the century Queen Victoria's eldest daughter the Empress Frederick acquired an early cast of the Woburn Le Sueur type for her historical collection at Schloss Friedrichshof[28] and in 1898 the Queen herself presented an electrotype by Elkington & Co. of the Bodleian model to Carisbrooke Castle, where it remains in a niche inscribed 'Remember' in the chapel dedicated to the King's memory by Princess Beatrice, then Governor of the Castle.[29]

JONATHAN MARSDEN

NOTES

1 Esdaile, 1949. The most recent survey is Howarth, 1989.

2 Avery, 1979 and Avery, 1982. On the equestrian statue in Trafalgar Square see Denoon, 1933.

3 Howarth, 1989, p. 85

4 These are the Bodleian (fig. 41), Woburn Abbey, Chichester and Stourhead types (Avery, 1982, nos 30-33).

5 Compare the busts of Lord Herbert of Cherbury and Sir Peter de Maire (Avery, 1982, nos 34-5).

6 The most distinguished of the group is the bust said to have been given to Strafford by the King (Avery, 1982, no. 30C). The type was re-coined on several subsequent occasions. A cast was noted in the Prussian royal *Kunstkammer* at Berlin in 1756 (see exh.cat. *Von Allen Seiten Schön*, Berlin, 1995 no. 186), and another (Avery, 1982, no. 31B), which belonged to Count Brühl, has been at Dresden since at least 1765; identical gilt plaster busts survive at St John's, Oxford, and elsewhere, and a bronzed plaster appeared at Christie's New York in 1994 (24 March, lot 39) paired with a similar bust of George III signed by Lawrence Gahagan; other bronzes are in the National Portrait Gallery (no. 297, stamped 'TT') and the Victoria & Albert Museum. Nineteenth-century French casts are at Kingston Lacy (by Forbier, 1839) and in the Royal Collection (by Duplan and Salles; RCIN 2126).

7 I am grateful to James Jackson, The Queen's Armourer, for explaining this technique.

8 The contemporary locations included Canterbury Quad at St John's College, Oxford (1634), the Whitehall Banqueting House, the Square Tower at Portsmouth (1635), the Market Cross at Chichester (1637), the Churchyard of St Paul's, Covent Garden, Inigo Jones's screen in Winchester Cathedral (1638), and Duke Humfrey's Library, Oxford (1641).

9 The other privately owned busts are those that are said to have been presented to Strafford (Avery, 1982, no. 30C) and to the 5th Earl of Bedford (Avery, 1982, no. 31A). It is tempting to speculate that Strafford's bust, which appears to have a weathered surface, once occupied the empty niche above the royal arms on the frontispiece of the King's Manor, York.

10 The busts were (i) an example of the 'Chichester' type (Millar, 1958-60, p. 40,

item 17); (ii) (in one of the window reveals of the Chair Room) a bust identified with the one at Stourhead (*ibid.*, p. 70); and (iii) (in the Cabinet Room) an unspecified type (*ibid.*, p. 97, no. 35).

11 Jutsham, *Receipts*, 1820, p. 97.

12 Jutsham, *Deliveries*, III, 1828, p. 185.

13 For the funerary effigy of James I, Le Sueur worked from a death-mask made by Maximilian Colt.

14 Cust, 1908, p. 339.

15 For the chronology see Lightbown, 1968 and Lightbown. 1981

16 Millar, 1970-2, p. 139, item 28; *Inventories of the Goods Recovered for His Gracious Majesty King Charles II ...* (typescript at Stable Yard House), p. 22; Bathoe, 1758, p. 102, no. 1259.

17 Vickers, 1978.

18 Raatschen, 1996.

19 Esdaile, 1938.

20 Esdaile, 1949. p. 13.

21 The busts both stand at Windsor on nineteenth-century pedestals (figs. 43-4) into which coats of arms of the same age as the busts have been let, below newly cut inscriptions that must have been associated with the busts in their first installation. The William III inscription (D.F.A /GUGLIELMO HENRICO./ D.G./P.ARAUSIO BELG CUB.M.BRI T.R./FIDEI LIBERTATISQ VINDICI. 1689) emphasises his Dutch honours and titles.

22 From the dealer Alfred Spero, without provenance.

23 Report by UCL Painting Analysis, 1998.

24 She was referring to the identical cast at Apothecaries Hall, which was formerly in the collection of Thomas G. Mackinlay (his sale Christie's, London, 7-10 March 1866). Lot 629: 'BUST OF CHARLES I, by BERNINI: the original model in terracotta, for which the celebrated picture of the heads of Charles was painted by Van Dyck'. Lot 630: 'A cast of the same – on scagliola pedestal'. The Apothecaries bust was presumably Lot 630.

25 Vertue, *Notebooks*, II, p. 50, and see Vickers, 1978, fig. 14.

26 See Ward-Jackson, 1992.

27 The Vyne cast is identical with one in the Gallery at Stratfield Saye, acquired by the 2nd Duke of Wellington, c.1882, from Colnaghi who bought it 'from Italy'.

28 See *Victoria & Albert*, 1996, no. IV/7.

29 Another Elkington example is in the Royal Collection (RCIN 2129).

Provenance

This exhibition provides a striking demonstration of the way in which the Royal Collection has evolved over the centuries. Two paintings and two miniatures are traceable in Van der Doort's inventory of Charles I's collection made in the late 1630s; although they were sold *c*.1650, they returned to the Royal Collection soon after the Restoration (pls 1, 6:10, 12 and fig. 15). The King also owned an impression of Robert van Voerst's print (fig. 16), and a number of coins and medals bearing his own portrait, but it is highly unlikely that the examples shown here were ever in his collection. Dobson's late portrait (fig. 21) may also have belonged to Charles I.

The tradition of gathering together portraits (whether painted, sculpted, minted or engraved) of members of the Royal Family is well founded in history. Although the original context of such works has long since disappeared, the collection of engraved royal portraits kept today in the Royal Library at Windsor is still organised in the traditional manner, i.e. chronologically by monarch, and also chronologically within the portraiture of each monarch. The manuscript inventory of 'Engravings at Buckingham House', made towards the end of George III's reign, includes ten prints that are also found in our exhibition selection.[1]

King George IV added a number of historical works to the collection, both before and after his accession in 1820. The oil by Pot (fig. 12) was purchased in 1814 with the Baring collection, Le Sueur's bronze (fig. 40) was acquired in 1820 and Van Dyck's triple portrait (pl. 5) in 1822. The Colnaghi invoices covering the formation of George IV's print collection also include a number of references to portraits of Charles I.[2]

The anonymous interior with portraits of the Earls of Pembroke (fig. 13) was acquired in 1888 by Queen Victoria. Records of acquisitions of prints are imprecise but the fact that the large copy (no. 83) of Hollar's memorial print bears the collector's mark of E.W. Martin suggests that it may have been acquired at one of the sales held after Martin's death in 1853.

George V's consort Queen Mary had a particular fondness for items of memorabilia relating to the Stuarts and arranged these in a room at Windsor Castle. Following the 1992 fire this space was replanned and its former contents are now normally displayed in the State Apartments at the Palace of Holyroodhouse, Edinburgh. Among the exhibits formerly listed as part of the 'Stuart Collection' are the enamel attributed to Petitot acquired in 1916 (pl. 7:17), Oliver's limning, acquired in 1920 (fig. 7) and many of the medals.

Queen Elizabeth The Queen Mother and Queen Elizabeth II have each acquired a number of portraits of Charles I. Thus the pair of marble busts of Charles I and William III (figs 43, 44) were purchased in 1937, the plaster bust (fig. 45) in 1947, Bower's portrait (fig. 22) in 1951, and the drawing by Hendrick Pot (pl. 4) in 1988. The fine full-length by Mytens (fig. 1) was bequeathed to HM The Queen in 1961, the electrotype copy of the Juxon medal (pl. 8:119) was donated in 1954 and the Oxford sixpence (no. 125) was presented by Spink & Son Ltd while preparations for this exhibition were under way.

NOTES

1. A volume covering the sixteenth and seventeenth centuries includes prints that are almost certainly identifiable with nos 31 (or 32 or 33), 35, 36, 37, 42 (or 43), 48, 49, 53, 57 and 58; Van Voerst's copy of Van Dyck's double portrait (no. 56) was included in the second volume of prints after Van Dyck (see 'Catalogue of Engravings, Buckingham House', MS in Windsor Print Room, vol. I, f. 55/63, p. 46, nos 41, 39, 40, 45, 46, 49, 52, 53, 54; f. 45/53, p. 44, no. 11).
2. These include a 'Portrait of Charles 1st by Faithorne' acquired for five guineas in March 1811 (RA 27610).

Exhibition list

OIL PAINTINGS

1 Daniel Mytens, *Charles I*, 1628. Oil on canvas, 219.4 x 139.1 cm (RCIN 404448; OM 118) **pl. 2 (det.); fig. 1**

2 Daniel Mytens with additions by Van Dyck, *Charles I and Henrietta Maria*, 1630–32. Oil on canvas, 95.6 x 175.3 cm (RCIN 405789; OM 119) **pl. 3 (det.); fig. 15**

3 Hendrick Pot, *Charles I, Henrietta Maria and Charles, Prince of Wales*, 1632. Oil on panel, 59.5 x 47 cm (RCIN 405541; CW 152) **fig. 12**

4 Unknown artists (? Jan van Belcamp and ?circle of Hendrick II van Steenwyck), *An interior with Charles I, Henrietta Maria, Jeffery Hudson and the 3rd and 4th Earls of Pembroke*, c.1635. Oil on canvas, 110.5 x 147.7 cm (RCIN 405296; OM 314) **fig. 13**

5 Sir Anthony van Dyck, *Charles I in three positions*, 1635. Oil on canvas, 84.5 x 99.7 cm (RCIN 404420; OM 146) **front cover (det.); pl. 5**

6 Sir Anthony van Dyck, *Charles I on horseback*, c.1637–38. Oil on canvas, 96.9 x 86.5 cm (RCIN 400571; OM 144) **pl. 1**

7 William Dobson, *Charles I in armour*, c.1642–46. Oil on canvas, 76.7 x 64.3 cm (RCIN 405828; OM 203) **fig. 21**

8 Edward Bower, *Charles I at his trial*, 1649. Oil on canvas, 131.1 x 99.2 cm (RCIN 405913; OM 208) **fig. 22**

MINIATURES AND ENAMELS

9 Circle of Nicholas Hilliard, *Charles I when Duke of York*, c.1611. Bodycolour on vellum, oval 3.5 x 2.7 cm (RCIN 420985; GR 41) **pl. 6**

10 Isaac Oliver, *Charles I when Duke of York*, c.1616. Bodycolour on vellum, oval 5.3 x 4.1 cm (RCIN 420048; GR 58) **pl. 6**

11 Peter Oliver, *Charles I when Prince of Wales*, c.1620. Bodycolour on vellum, oval 5 x 4 cm (RCIN 420049; GR 66) **pl. 6**

12 Peter Oliver, *Charles I when Prince of Wales*, 1621. Bodycolour on vellum, oval 5.2 x 4.4 cm (RCIN 420055; GR 67) **pl. 6**

13 Peter Oliver, *Charles I when Prince of Wales*, c.1622/3. Bodycolour on vellum, oval 5.5 x 4.1 cm (RCIN 420942; GR 69) **pl. 6**

14 Peter Oliver after Mytens, *Charles I*, c.1625/30. Bodycolour on vellum, oval 3.8 x 2.9 cm (RCIN 420050; GR 70) **pl. 7**

15 Peter Oliver after Mytens, *Charles I*, c.1630. Brush and ink with touches of graphite and grey wash, oval 8.3 x 6.6 cm (RL 17628; OE 469) **fig. 7**

16 Attributed to John Hoskins, *Charles I*, c.1634. Bodycolour on vellum, oval 2.6 x 2.1 cm (RCIN 420059; GR 90) **pl. 7**

17 Attributed to Jean Petitot, *Charles I*, c.1642. Enamel, oval 4 x 3.3 cm (RCIN 421355; GR 347) **pl. 7**

18 John Hoskins, *Charles I*, c.1645. Bodycolour on vellum, oval 7.4 x 6 cm (RCIN 420060; GR 80) **pl. 7**

19 Style of Jean Petitot after Van Dyck, *Charles I*, c.1650–1700. Enamel, oval 3.2 x 2.7 cm (RCIN 421745; GR 348) **pl. 7**

20 After Van Dyck, *Charles I*, c.1650–1700. Enamel, oval 3 x 2.5 cm (RCIN 420897; GR 406) **pl. 7**

21 After Van Dyck, *Memorial portrait of Charles I*, late seventeenth century. Enamel, oval 3 x 2.4, within octagonal crystal frame (RCIN 421040; GR 407)

22 *The 'Passion' of Charles I*, late seventeenth century. Oil on copper, oval 8 x 6.3 cm, with 12 mica overlays painted with oil paint, within oval tooled shagreen case (RCIN 422099; GR 446)

DRAWING

23 Hendrick Pot, *Charles I*, 1632. Coloured chalks on blue paper faded to grey-brown, 35 x 26.5 cm (RL 28706; W&C 421A) **pl. 4**

PRINTS

In the following section dimensions relate to the platemark unless otherwise specified

24 Anonymous, *The English royal lineage from Matilda to Henry, Prince of Wales*, c.1604. Engraving, 54.5 x 38.4 cm (RCIN 601408)

25 Willem de Passe, *The family of James VI and I ('Triumphus Jacobi Regis')*, c.1623/4. Engraving with etching, sheet 32.1 x 38.5 cm. Published by Thomas Jenner and John Bill (RCIN 601472; Hind, II, pp. 295–7, no. 15.I; Hollstein 46.I) **fig. 24**

26 Gerrit Mountain, *The family of James VI and I ('The progenie of the most renowned Prince James King of Great Britaine France and Ireland')*, c.1633/4. Engraving, sheet 33.3 x 46.3 cm. Published by William Riddiard, with verses by John Webster (RCIN 601474; Hind, II, pp. 311–12, no. 5)

27 Unknown engraver and Cornelis Boel, *Charles I when Duke of York*, c.1613. Engraving, sheet 23.4 x 15.8 cm. Published by John Boswell (RCIN 601495; Hind, II, pp. 314–15, no. 2 undescribed state between III and IV) **fig. 2**

28 Cornelis Boel, *Henry, Prince of Wales*, c.1611. Engraving, sheet 23.5 x 16 cm. Published by John Boswell (RCIN 601450; Hind, II, pp. 314–15, no. 2.III)

29 Renold Elstrack, *Charles I when Duke of York*, c.1614. Engraving, 19.3 x 15.9 cm (RCIN 601501; Hind, II, pp. 157–8, no. 8.I)

30 Renold Elstrack, *Charles I when Duke of York, on horseback*, c.1614. Engraving, 26.1 x 18.7 cm. Published by John Sudbury and George Humble (RCIN 601837; Hind, II, p. 168, no. 10.I) **fig. 25**

31 Simon de Passe, *Charles I when Prince of Wales*, 1616. Engraving, 18.1 x 11.4 cm. Published by Compton Holland (RCIN 680496; Hind, II, p. 133, no. 28.I; Hollstein 38.I) **fig. 3**

32 Simon de Passe, *Charles I when Prince of Wales*, c.1618. Engraving, 18.2 x 11.3 cm. Published by Compton Holland (RCIN 680688; Hind, II, p. 133, no. 28.II; Hollstein 38.II)

33 Simon de Passe and unknown engraver, *Charles I when Prince of Wales*, c.1622. Engraving, 18.3 x 11.5 cm. Published by Compton Holland (RCIN 680689; Hind, II, p. 133, no. 28.III; Hollstein 38.III) **fig. 4**

34 Francis Delaram after Simon de Passe, *Charles I when Prince of Wales*, 1616. Engraving, 19.3 x 12.1 cm (RCIN 601497; Hind, II, p. 217, no. 5)

35 Simon de Passe, *Charles I when Prince of Wales*, 1622. Engraving, 16.8 x 11 cm. Published by Crispijn de Passe (RCIN 601511; Hind, II, p. 42, no. 5; Hollstein 39)

36 Simon de Passe, *The Infanta Maria, later Empress Maria of Austria*, 1622. Engraving, 16.5 x 10.9 cm. Published by Crispijn de

MISCELLANEOUS SMALL OBJECTS

(1) Plaques, coins and medals

114 Simon de Passe, *Plaque showing James I, Anne of Denmark and Prince Charles*, c.1616. Silver, ?engraved, oval 6.2 x 5.1 cm. Reverse: *royal arms, etc.* (RCIN 29218; *MI*, pl. XVI/6. Exhibited with paper impression, 601477; Hind, II, p. 279, no. 5; Hollstein 71)

115 Simon de Passe, *Plaque of Charles I when Prince of Wales*, 1616. Silver, ?engraved, oval 5.4 x 4.2 cm. Reverse: *royal arms* (RCIN 443080; *MI*, pl. XVI/4. Exhibited with paper impression of later state, 601517; Hind, II, p. 279, no. 6; Hollstein 36)

116 Simon de Passe, *Plaque of Charles I when Prince of Wales*, c.1621. Silver, ?engraved, oval 6 x 4.9 cm. Reverse: *equestrian image* (RCIN 443081; *MI*, pl. XVI/5. Exhibited and reproduced with paper impressions, RCIN 601844, 601499; Hind, II, p. 279, no. 7; Hollstein 40) **fig. 23**

117 *One pound coin of Charles I*, 1625. Mintmark lis. Gold, struck, diameter 3.5 cm. Reverse: *royal arms* (RCIN 443110; Seaby 2688)

118 Nicolas Briot, *Medal commemorating the English coronation of Charles I*, 1626. Gold, struck, diameter 3 cm. Reverse: *arm brandishing sword, issuing from clouds* (RCIN 443108; *MI*, pl. XX/1) **pl. 8**

119 Attributed to Abraham van der Doort, *Charles I pattern five pound piece ('the Juxon medal')*, 1631–32. Mintmark rose. Silvered copper with lead core (electrotype copy of gold original, struck, in British Museum: *MI*, pl. XXXIII/21), diameter 3.9 cm. Reverse: *royal arms* (RCIN 443107) **pl. 8**

120 Nicolas Briot, *Medal commemorating the Scottish coronation of Charles I*, 1633. Gold, struck, diameter 2.8 cm. Reverse: *a thistle and rose tree united on a single stem* (RCIN 443093; *MI*, pl. XXII/2) (obverse exhibited) **pl. 8**

121 Nicolas Briot, *Medal commemorating the Scottish coronation of Charles I*, 1633. Silver, struck, diameter 2.8 cm. Reverse: *a thistle and rose tree united on a single stem* (RCIN 443097; *MI*, pl. XXII/2) (reverse exhibited)

122 Nicolas Briot, *Medal commemorating Charles I's return to London following the Scottish coronation*, 1633. Gold, struck, diameter 4.2 cm. Reverse: *view of London from the south* (RCIN 443109; *MI*, pl. XXII/4) (obverse exhibited) **pl. 8**

123 Nicolas Briot, *Medal commemorating Charles I's return to London following the Scottish coronation*, 1633. Silver, cast and chased, diameter 4.2 cm. Reverse: *view of London from the south* (RCIN 443095; *MI*, pl. XXII/4) (reverse exhibited)

124 Nicolas Briot, *Dominion of the Sea medal*, 1639. Silver, cast and chased, diameter 5.9 cm. Reverse: *a ship in full sail* (RCIN 443089; *MI*, pl. XXIV/10) **pl. 8**

125 *Sixpence of Charles I*, 1643. Mintmark Oxford plumes. Silver, struck, diameter 2.8 cm. Reverse: *lettering* (RCIN 443548; Seaby 2980)

(2) Royalist badges, memorabilia and miscellanea

126 Attributed to Thomas Rawlins, *Charles I medal*, 1630s/1640s. Reverse: *royal arms*. Silver, cast and chased, diameter 3.4 cm (RCIN 443106; *MI*, pl. XXXIII/17) **pl. 8**

127 Thomas Rawlins, *Charles I royalist badge*, 1640s. Reverse: *Henrietta Maria*. Gilt brass, cast and chased, with pearl drop, oval 4.9 x 3.2 cm (RCIN 43832; *MI*, pl. XXXI/5)

128 Thomas Rawlins, *Charles I royalist badge*, 1640s. Reverse: *Henrietta Maria*. Silver, cast and chased, oval 4.2 x 3.1 cm (RCIN 443104; *MI*, pl. XXXI/5)

129 Thomas Rawlins, *Charles I royalist badge*, 1640s. Reverse: *royal arms*. Gold, cast and chased, with pearl drop, oval 5.4 x 3.4 cm (RCIN 28983; *MI*, pl. XXXII/8) **pl. 8**

130 Thomas Rawlins, *Charles I royalist badge*, 1640s. Reverse: *royal arms*. Silver, cast and chased, oval 5.3 x 3.6 cm, on necklace of amber and silver (RCIN 28980; *MI*, pl. XXXII/9)

131 Attributed to Thomas Rawlins, *Charles I royalist badge*, 1640s. Reverse: *royal arms*. Silver, cast and chased, oval 2.7 x 2 cm (RCIN 443105; *MI*, pl. XXXII/13) **pl. 8**

132 Attributed to Thomas Rawlins, *Charles I royalist badge*, 1640s. Reverse: *royal arms*. Silver, cast, chased, and gilt, oval 2.8 x 2 cm (RCIN 43831; *MI*, pl. XXXII/13) **pl. 8**

133 Attributed to Thomas Rawlins, *Charles I royalist badge*, 1640s. Reverse: *royal arms*. Base metal, cast, oval 1.5 x 1.2 cm (RCIN 37055; *MI*, pl. XXXII/18) **pl. 8**

134 *Charles I memorial medallion*, late seventeenth century. Silver gilt, pierced and engraved; the central medallion attributed to Thomas Rawlins, gold, cast and chased; oval 8.9 x 6.4 cm (RCIN 43860. For the medallion cf. *MI*, pls XXVI/18 of 1643 or XXX/19 of 1649) **pl. 8**

135 *Tobacco box incorporating profile portrait of Charles I*, 1640s–80s. Gold, pierced and engraved, oval 8.1 x 6.4 x 1.7 cm (RCIN 28977)

136 *Tobacco box incorporating profile portrait of Charles I*, 1640s–80s. Silver, pierced and engraved, oval 8.1 x 6.4 x 1.8 cm (RCIN 28975)

137 *Inscribed box with Charles I fob ornament*, 1650s. Box: gold (stamped IC), engraved with niello, 4 x 1.4 x 1.2 cm. Fob ornament: gold finger ring, re-formed, with enamelled portrait and crowned skull; separate crown, enamelled gold (RCIN 43840) **pl. 8**

138 *Charles I memorial ring*, c.1650–1700. Portrait: enamel, oval 1.6 x 0.8 cm; ring: gold, diameter 2 cm (RCIN 422290)

139 *Portrait of Charles I embroidered in hair*, 1650s. Hair applied to card, 9 x 7.5 cm (RCIN 63733)

140 *Snuff-box with portrait of Charles I*, 1650s. Oak with cast silver portrait, 9.6 x 7.2 x 3.8 cm (RCIN 43857)

141 Jan Roettiers, *Charles I memorial medal*, c.1670. Reverse: *arm holding celestial crown, issuing from clouds, sheep below*. Copper gilt, struck, diameter 5 cm (RCIN 443101; *MI*, pl. XXX/11)

142 *Circular box (with portraits of Charles I on lid, and Henrietta Maria on base) containing 36 counters of the Sovereigns of England from Edward the Confessor to Charles I*. Box: silver, pierced and engraved, with cast portraits on lid and base, 1630s, diameter 3.1 cm, height 2.4 cm. Counters: De Passe workshop, silver, ?engraved, c.1632, diameter variable, 2.5 to 2.7 cm (RCIN 28997. Box: *MI*, pl. XXXIV/18. Counters: including *MI*, pl. XXXIV/9–10) **pl. 8 (lid)**

143 De Passe workshop, *Part set of five circular counters*, c.1616–30. Silver, ?engraved, diameter c.26 mm. (i) *James I*. Reverse: *Charles I when Prince of Wales* (*MI*, pl. XXXIV/1). Reverse exhibited; (ii) *James I*. Reverse: *Charles I when Prince of Wales* (*MI*, pl. XXXIV/1). Reverse exhibited; pierced for hanging; (iii) *Charles I*. Reverse: *Henrietta Maria* (*MI*, pl. XXXIV/3–5); (iv) *Charles I and Henrietta Maria*. Reverse: *three crowns on crossed swords* (*MI*, pl. XXXIV/6); (v) *Charles I and Henrietta Maria*. Reverse: *arms of Britain and France* (*MI*, pl. XXXIV/7) (from RCIN 43847)

Exhibition list

OIL PAINTINGS

1. Daniel Mytens, *Charles I*, 1628. Oil on canvas, 219.4 x 139.1 cm (RCIN 404448; OM 118) **pl. 2 (det.); fig. 1**

2. Daniel Mytens with additions by Van Dyck, *Charles I and Henrietta Maria*, 1630–32. Oil on canvas, 95.6 x 175.3 cm (RCIN 405789; OM 119) **pl. 3 (det.); fig. 15**

3. Hendrick Pot, *Charles I, Henrietta Maria and Charles, Prince of Wales*, 1632. Oil on panel, 59.5 x 47 cm (RCIN 405541; CW 152) **fig. 12**

4. Unknown artists (? Jan van Belcamp and ?circle of Hendrick II van Steenwyck), *An interior with Charles I, Henrietta Maria, Jeffery Hudson and the 3rd and 4th Earls of Pembroke*, c.1635. Oil on canvas, 110.5 x 147.7 cm (RCIN 405296; OM 314) **fig. 13**

5. Sir Anthony van Dyck, *Charles I in three positions*, 1635. Oil on canvas, 84.5 x 99.7 cm (RCIN 404420; OM 146) **front cover (det.); pl. 5**

6. Sir Anthony van Dyck, *Charles I on horseback*, c.1637–38. Oil on canvas, 96.9 x 86.5 cm (RCIN 400571; OM 144) **pl. 1**

7. William Dobson, *Charles I in armour*, c.1642–46. Oil on canvas, 76.7 x 64.3 cm (RCIN 405828; OM 203) **fig. 21**

8. Edward Bower, *Charles I at his trial*, 1649. Oil on canvas, 131.1 x 99.2 cm (RCIN 405913; OM 208) **fig. 22**

MINIATURES AND ENAMELS

9. Circle of Nicholas Hilliard, *Charles I when Duke of York*, c.1611. Bodycolour on vellum, oval 3.5 x 2.7 cm (RCIN 420985; GR 41) **pl. 6**

10. Isaac Oliver, *Charles I when Duke of York*, c.1616. Bodycolour on vellum, oval 5.3 x 4.1 cm (RCIN 420048; GR 58) **pl. 6**

11. Peter Oliver, *Charles I when Prince of Wales*, c.1620. Bodycolour on vellum, oval 5 x 4 cm (RCIN 420049; GR 66) **pl. 6**

12. Peter Oliver, *Charles I when Prince of Wales*, 1621. Bodycolour on vellum, oval 5.2 x 4.4 cm (RCIN 420055; GR 67) **pl. 6**

13. Peter Oliver, *Charles I when Prince of Wales*, c.1622/3. Bodycolour on vellum, oval 5.5 x 4.1 cm (RCIN 420942; GR 69) **pl. 6**

14. Peter Oliver after Mytens, *Charles I*, c.1625/30. Bodycolour on vellum, oval 3.8 x 2.9 cm (RCIN 420050; GR 70) **pl. 7**

15. Peter Oliver after Mytens, *Charles I*, c.1630. Brush and ink with touches of graphite and grey wash, oval 8.3 x 6.6 cm (RL 17628; OE 469) **fig. 7**

16. Attributed to John Hoskins, *Charles I*, c.1634. Bodycolour on vellum, oval 2.6 x 2.1 cm (RCIN 420059; GR 90) **pl. 7**

17. Attributed to Jean Petitot, *Charles I*, c.1642. Enamel, oval 4 x 3.3 cm (RCIN 421355; GR 347) **pl. 7**

18. John Hoskins, *Charles I*, c.1645. Bodycolour on vellum, oval 7.4 x 6 cm (RCIN 420060; GR 80) **pl. 7**

19. Style of Jean Petitot after Van Dyck, *Charles I*, c.1650–1700. Enamel, oval 3.2 x 2.7 cm (RCIN 421745; GR 348) **pl. 7**

20. After Van Dyck, *Charles I*, c.1650–1700. Enamel, oval 3 x 2.5 cm (RCIN 420897; GR 406) **pl. 7**

21. After Van Dyck, *Memorial portrait of Charles I*, late seventeenth century. Enamel, oval 3 x 2.4, within octagonal crystal frame (RCIN 421040; GR 407)

22. *The 'Passion' of Charles I*, late seventeenth century. Oil on copper, oval 8 x 6.3 cm, with 12 mica overlays painted with oil paint; within oval tooled shagreen case (RCIN 422099; GR 446)

DRAWING

23. Hendrick Pot, *Charles I*, 1632. Coloured chalks on blue paper faded to grey-brown, 35 x 26.5 cm (RL 28706; W&C 421A) **pl. 4**

PRINTS

In the following section dimensions relate to the platemark unless otherwise specified

24. Anonymous, *The English royal lineage from Matilda to Henry, Prince of Wales*, c.1604. Engraving, 54.5 x 38.4 cm (RCIN 601408)

25. Willem de Passe, *The family of James VI and I ('Triumphus Jacobi Regis')*, c.1623/4. Engraving with etching, sheet 32.1 x 38.5 cm. Published by Thomas Jenner and John Bill (RCIN 601472; Hind, II, pp. 295–7, no. 15.I; Hollstein 46.I) **fig. 24**

26. Gerrit Mountain, *The family of James VI and I ('The progenie of the most renowned Prince James King of Great Britaine France and Ireland')*, c.1633/4. Engraving, sheet 33.3 x 46.3 cm. Published by William Riddiard, with verses by John Webster (RCIN 601474; Hind, II, pp. 311–12, no. 5)

27. Unknown engraver and Cornelis Boel, *Charles I when Duke of York*, c.1613. Engraving, sheet 23.4 x 15.8 cm. Published by John Boswell (RCIN 601495; Hind, II, pp. 314–15, no. 2 undescribed state between III and IV) **fig. 2**

28. Cornelis Boel, *Henry, Prince of Wales*, c.1611. Engraving, sheet 23.5 x 16 cm. Published by John Boswell (RCIN 601450; Hind, II, pp. 314–15, no. 2.III)

29. Renold Elstrack, *Charles I when Duke of York*, c.1614. Engraving, 19.3 x 15.9 cm (RCIN 601501; Hind, II, pp. 157–8, no. 8.I)

30. Renold Elstrack, *Charles I when Duke of York, on horseback*, c.1614. Engraving, 26.1 x 18.7 cm. Published by John Sudbury and George Humble (RCIN 601837; Hind, II, p. 168, no. 10.I) **fig. 25**

31. Simon de Passe, *Charles I when Prince of Wales*, 1616. Engraving, 18.1 x 11.4 cm. Published by Compton Holland (RCIN 680496; Hind, II, p. 133, no. 28.I; Hollstein 38 I) **fig. 3**

32. Simon de Passe, *Charles I when Prince of Wales*, c.1618. Engraving, 18.2 x 11.3 cm. Published by Compton Holland (RCIN 680688; Hind, II, p. 133, no. 28.II; Hollstein 38.II)

33. Simon de Passe and unknown engraver, *Charles I when Prince of Wales*, c.1622. Engraving, 18.3 x 11.5 cm. Published by Compton Holland (RCIN 680689; Hind, II, p. 133, no. 28.III; Hollstein 38.III) **fig. 4**

34. Francis Delaram after Simon de Passe, *Charles I when Prince of Wales*, 1616. Engraving, 19.3 x 12.1 cm (RCIN 601497; Hind, II, p. 217, no. 5)

35. Simon de Passe, *Charles I when Prince of Wales*, 1622. Engraving, 16.8 x 11 cm. Published by Crispijn de Passe (RCIN 601511; Hind, II, p. 42, no. 5; Hollstein 39)

36. Simon de Passe, *The Infanta Maria, later Empress Maria of Austria*, 1622. Engraving, 16.5 x 10.9 cm. Published by Crispijn de

MISCELLANEOUS SMALL OBJECTS

(1) Plaques, coins and medals

114 Simon de Passe, *Plaque showing James I, Anne of Denmark and Prince Charles, c.*1616. Silver, ?engraved, oval 6.2 x 5.1 cm. Reverse: *royal arms*, etc. (RCIN 29218; *MI*, pl. XVI/6. Exhibited with paper impression, 601477; Hind, II, p. 279, no. 5; Hollstein 71)

115 Simon de Passe, *Plaque of Charles I when Prince of Wales,* 1616. Silver, ?engraved, oval 5.4 x 4.2 cm. Reverse: *royal arms* (RCIN 443080; *MI*, pl. XVI/4. Exhibited with paper impression of later state, 601517; Hind, II, p. 279, no. 6; Hollstein 36)

116 Simon de Passe, *Plaque of Charles I when Prince of Wales, c.*1621. Silver, ?engraved, oval 6 x 4.9 cm. Reverse: *equestrian image* (RCIN 443081; *MI*, pl. XVI/5. Exhibited and reproduced with paper impressions, RCIN 601844, 601499; Hind, II, p. 279, no. 7; Hollstein 40) **fig. 23**

117 *One pound coin of Charles I,* 1625. Mintmark lis. Gold, struck, diameter 3.5 cm. Reverse: *royal arms* (RCIN 443110; Seaby 2688)

118 Nicolas Briot, *Medal commemorating the English coronation of Charles I,* 1626. Gold, struck, diameter 3 cm. Reverse: *arm brandishing sword, issuing from clouds* (RCIN 443108; *MI*, pl. XX/1) **pl. 8**

119 Attributed to Abraham van der Doort, *Charles I pattern five pound piece ('the Juxon medal'),* 1631–32. Mintmark rose. Silvered copper with lead core (electrotype copy of gold original, struck, in British Museum: *MI*, pl. XXXIII/21), diameter 3.9 cm. Reverse: *royal arms* (RCIN 443107) **pl. 8**

120 Nicolas Briot, *Medal commemorating the Scottish coronation of Charles I,* 1633. Gold, struck, diameter 2.8 cm. Reverse: *a thistle and rose tree united on a single stem* (RCIN 443093; *MI*, pl. XXII/2) (obverse exhibited) **pl. 8**

121 Nicolas Briot, *Medal commemorating the Scottish coronation of Charles I,* 1633. Silver, struck, diameter 2.8 cm. Reverse: *a thistle and rose tree united on a single stem* (RCIN 443097; *MI*, pl. XXII/2) (reverse exhibited)

122 Nicolas Briot, *Medal commemorating Charles I's return to London following the Scottish coronation,* 1633. Gold, struck, diameter 4.2 cm. Reverse: *view of London from the south* (RCIN 443109; *MI*, pl. XXII/4) (obverse exhibited) **pl. 8**

123 Nicolas Briot, *Medal commemorating Charles I's return to London following the Scottish coronation,* 1633. Silver, cast and chased, diameter 4.2 cm. Reverse: *view of London from the south* (RCIN 443095; *MI*, pl. XXII/4) (reverse exhibited)

124 Nicolas Briot, *Dominion of the Sea medal,* 1639. Silver, cast and chased, diameter 5.9 cm. Reverse: *a ship in full sail* (RCIN 443089; *MI*, pl. XXIV/10) **pl. 8**

125 *Sixpence of Charles I,* 1643. Mintmark Oxford plumes. Silver, struck, diameter 2.8 cm. Reverse: *lettering* (RCIN 443548; Seaby 2980)

(2) Royalist badges, memorabilia and miscellanea

126 Attributed to Thomas Rawlins, *Charles I medal,* 1630s/1640s. Reverse: *royal arms.* Silver, cast and chased, diameter 3.4 cm (RCIN 443106; *MI*, pl. XXXIII/17) **pl. 8**

127 Thomas Rawlins, *Charles I royalist badge,* 1640s. Reverse: *Henrietta Maria.* Gilt brass, cast and chased, with pearl drop, oval 4.9 x 3.2 cm (RCIN 43832; *MI*, pl. XXXI/5)

128 Thomas Rawlins, *Charles I royalist badge,* 1640s. Reverse: *Henrietta Maria.* Silver, cast and chased, oval 4.2 x 3.1 cm (RCIN 443104; *MI*, pl. XXXI/5)

129 Thomas Rawlins, *Charles I royalist badge,* 1640s. Reverse: *royal arms.* Gold, cast and chased, with pearl drop, oval 5.4 x 3.4 cm (RCIN 28983; *MI*, pl. XXXII/8) **pl. 8**

130 Thomas Rawlins, *Charles I royalist badge,* 1640s. Reverse: *royal arms.* Silver, cast and chased, oval 5.3 x 3.6 cm, on necklace of amber and silver (RCIN 28980; *MI*, pl. XXXII/9)

131 Attributed to Thomas Rawlins, *Charles I royalist badge,* 1640s. Reverse: *royal arms.* Silver, cast and chased, oval 2.7 x 2 cm (RCIN 443105; *MI*, pl. XXXII/13) **pl. 8**

132 Attributed to Thomas Rawlins, *Charles I royalist badge,* 1640s. Reverse: *royal arms.* Silver, cast, chased, and gilt, oval 2.8 x 2 cm (RCIN 43831; *MI*, pl. XXXII/13) **pl. 8**

133 Attributed to Thomas Rawlins, *Charles I royalist badge,* 1640s. Reverse: *royal arms.* Base metal, cast, oval 1.5 x 1.2 cm (RCIN 37055; *MI*, pl. XXXII/18) **pl. 8**

134 *Charles I memorial medallion,* late seventeenth century. Silver gilt, pierced and engraved; the central medallion attributed to Thomas Rawlins, gold, cast and chased; oval 8.9 x 6.4 cm (RCIN 43860. For the medallion cf. *MI*, pls XXVI/18 of 1643 or XXX/19 of 1649) **pl. 8**

135 *Tobacco box incorporating profile portrait of Charles I,* 1640s–80s. Gold, pierced and engraved, oval 8.1 x 6.4 x 1.7 cm (RCIN 28977)

136 *Tobacco box incorporating profile portrait of Charles I,* 1640s–80s. Silver, pierced and engraved, oval 8.1 x 6.4 x 1.8 cm (RCIN 28975)

137 *Inscribed box with Charles I fob ornament,* 1650s. Box: gold (stamped IC), engraved with niello, 4 x 1.4 x 1.2 cm. Fob ornament: gold finger ring, re-formed, with enamelled portrait and crowned skull; separate crown, enamelled gold (RCIN 43840) **pl. 8**

138 *Charles I memorial ring, c.*1650–1700. Portrait: enamel, oval 1.6 x 0.8 cm; ring: gold, diameter 2 cm (RCIN 422290)

139 *Portrait of Charles I embroidered in hair,* 1650s. Hair applied to card, 9 x 7.5 cm (RCIN 63733)

140 *Snuff-box with portrait of Charles I,* 1650s. Oak with cast silver portrait, 9.6 x 7.2 x 3.8 cm (RCIN 43857)

141 Jan Roettiers, *Charles I memorial medal, c.*1670. Reverse: *arm holding celestial crown, issuing from clouds, sheep below.* Copper gilt, struck, diameter 5 cm (RCIN 443101; *MI,* pl. XXX/11)

142 *Circular box (with portraits of Charles I on lid, and Henrietta Maria on base) containing 36 counters of the Sovereigns of England from Edward the Confessor to Charles I.* Box: silver, pierced and engraved, with cast portraits on lid and base, 1630s, diameter 3.1 cm, height 2.4 cm. Counters: De Passe workshop, silver, ?engraved, c.1632, diameter variable, 2.5 to 2.7 cm (RCIN 28997. Box: *MI,* pl. XXXIV/18. Counters: including *MI,* pl. XXXIV/9-10) **pl. 8 (lid)**

143 De Passe workshop, *Part set of five circular counters, c.*1616-30. Silver, ?engraved, diameter c.26 mm. (i) *James I.* Reverse: *Charles I when Prince of Wales* (*MI,* pl. XXXIV/1). Reverse exhibited; (ii) *James I.* Reverse: *Charles I when Prince of Wales* (*MI,* pl. XXXIV/1). Reverse exhibited; pierced for hanging; (iii) *Charles I.* Reverse: *Henrietta Maria* (*MI,* pl. XXXIV/3–5); (iv) *Charles I and Henrietta Maria.* Reverse: *three crowns on crossed swords* (*MI,* pl. XXXIV/6); (v) *Charles I and Henrietta Maria.* Reverse: *arms of Britain and France* (*MI,* pl. XXXIV/7) (from RCIN 43847)

Bibliography and abbreviations

Allen, 1941 D.F. Allen, 'Abraham Vanderdort and the Coinage of Charles I', *Numismatic Chronicle*, n.s. 5, i, pp. 54–75

Auerbach, 1961 E. Auerbach, *Nicholas Hilliard*, London

Avery, 1979 C. Avery, 'Hubert Le Sueur's portraits of King Charles I in Bronze', *National Trust Studies*, pp. 128–47

Avery, 1982 C. Avery, 'Hubert Le Sueur, the "unworthy Praxiteles of King Charles I"', *Walpole Society*, XLVIII, pp. 135–209

Bathoe, 1758 W. Bathoe, *A Catalogue of the Collection of Pictures ... belonging to King James the Second*, London

Beddard, 1984 R.A. Beddard, 'Wren's mausoleum for Charles I and the cult of the Royal Martyr', *Architectural History*, 27, pp. 36–47

Berghaus, 1989 G. Berghaus, *Die Aufnahme der englischen Revolution in Deutschland 1640–1669*, Wiesbaden

BM Sat F.G. Stephens, *Catalogue of Prints and Drawings in the British Museum: Satirical and Personal Subjects*, I (1320–1689), London, 1870

Brown, 1991 C. Brown, *The Drawings of Anthony van Dyck*, exh. cat., Pierpont Morgan Library, New York

Carpenter, 1844 W.H. Carpenter, *Pictorial Notices: consisting of a Memoir of Sir Anthony Van Dyck*, London

CS J. Chaloner Smith, *British Mezzotinto Portraits, from the Introduction of the Art to the Early Part of the Present Century*, 4 vols, London, 1883

Cumming, 1989 V. Cumming, '"Great vanity and excesse in Apparell". Some clothing and furs of Tudor and Stuart Royalty', in MacGregor, 1989, pp. 322–50

Cust, 1908 L. Cust, 'Notes on pictures in the Royal Collection XIII: The triple portrait of Charles I by Van Dyck and the bust by Bernini', *Burlington Magazine*, XIV, pp. 337–40

CW C. White, *The Dutch Pictures in the Collection of Her Majesty The Queen*, Cambridge and London, 1982

Dawn, 1993 *Dawn of the Golden Age. Northern Netherlandish Art 1580–1620*, exh. cat., Amsterdam

Denoon, 1933 D.G. Denoon, 'The statue of Charles I at Charing Cross', *Transactions of the London and Middlesex Archaeological Society*, n.s., VI, pp. 460–86

D'Israeli, 1830 I. D'Israeli, *Commentaries on the life and reign of Charles the First*, London

Dynasties, 1995 *Dynasties. Painting in Tudor and Jacobean England 1530–1630*, exh. cat., ed. K. Hearn, Tate Gallery, London

Esdaile, 1938 K.A. Esdaile, 'Two busts of Charles I and William III', *Burlington Magazine*, LXXII, pp. 164–71

Esdaile, 1949 K.A. Esdaile, 'The busts and statues of Charles I' *Burlington Magazine*, XCI, pp. 9–14

Farquhar, 1906 H. Farquhar, 'Portraiture of the Stuarts on the royalist badges', *British Numismatic Journal*, II, pp. 243–90

Farquhar, 1909 H. Farquhar, 'Portraiture of our Stuart Monarchs on their Coins and Medals', *British Numismatic Journal*, V, pp. 145–262

Farquhar, 1916 H. Farquhar, 'Silver Counters of the Seventeenth Century', *Numismatic Chronicle*, ser. IV, XVI, pp. 133–93

Fellowes, 1944 E.H. Fellowes, *The Military Knights of Windsor, 1352–1944*, Windsor

Fortescue, 1908 G.K. Fortescue, *Catalogue of the Pamphlets, Books, Newspapers ... collected by George Thomason 1640–61*, London

Globe A. Globe, *Peter Stent, London Printseller, circa 1642–1665*, Vancouver, 1985

GR Graham Reynolds, *The Miniatures in the Collection of H.M. The Queen. The Sixteenth and Seventeenth Centuries*, London, 1999 (forthcoming)

Griffiths, 1998 A. Griffiths, *The Print in Stuart Britain 1603–1689*, exh. cat., British Museum, London

Halford, 1831 H. Halford, 'An Account of what appeared on opening the coffin of King Charles I', in *Essays and Orations*

Hind A.M. Hind, *Engraving in England in the Sixteenth and Seventeenth Centuries*, Cambridge, 1952–55, 2 vols; vol. III (compiled from Hind's notes by M. Corbett and M. Norton), Cambridge, 1964

Hollstein F.W.H. Hollstein, *Dutch and Flemish Etchings, Engravings and Woodcuts c.1450–1700*, Amsterdam, 1949–

Howarth, 1989 D. Howarth, 'Charles I, sculpture and sculptors', in MacGregor, 1989, pp. 73–113

Howarth, 1997 D. Howarth, *Images of Rule. Art and Politics in the English Renaissance 1485–1649*, London

Inigo Jones, 1973 *The King's Arcadia: Inigo Jones and the Stuart Court*, exh. cat. by J. Harris, S. Orgel and R. Strong, London

Jones, 1983 M. Jones, 'The technique of Simon van de Passe reconsidered', *Numismatic Chronicle*, 143, pp. 227–30

Jutsham, Deliveries Benjamin Jutsham, *An Account of furniture & despatched from Carlton House 1807–1830*, 2 vols, MS in Stable Yard House

Jutsham, Receipts Benjamin Jutsham, *An Account of furniture & received at Carlton House 1806–1829*, 2 vols, MS in Stable Yard House

Layard G.S. Layard, *Catalogue Raisonné of Engraved Portraits from Altered Plates*, London 1927

Layard, 1922 G.S. Layard, *The Headless Horseman. Pierre Lombart's Engraving. Charles or Cromwell?*, London

Lightbown, 1968 R. Lightbown, 'The journey of the Bernini bust of Charles I to England', *The Connoisseur*, 169, pp. 217–20

Lightbown, 1970 R. Lightbown, 'Jean Petitot. Etude pour une biographie et catalogue de son oeuvre', *Genava*, n.s., XVIII, i, pp. 81–103

Lightbown, 1981 R. Lightbown, 'Bernini's busts of English sitters', in *Art the Ape of Nature: studies in honor of H.W. Janson*, New York, pp. 439–76

Lightbown, 1989 (1) R. Lightbown, 'Charles I and the tradition of European princely collecting', in MacGregor, 1989, pp. 53–72

Lightbown, 1989 (2) R. Lightbown, 'Charles I and the Art of the Goldsmith', in MacGregor, 1989, pp. 233–55

MacGregor, 1989 *The Late King's Goods. Collections, Possessions and Patronage of Charles I in the Light of the Commonwealth Sale Inventories*, ed. A. MacGregor, London and Oxford

Madan F.F. Madan, *A new bibliography of the Eikon Basilike*, Oxford, 1950

Martin, 1987 M. Martin, 'The Case of the Missing Woodcuts', *Print Quarterly*, IV, no. 4, pp. 343–61

M-H M. Mauquoy-Hendrickx, *L'Iconographie d'Antoine Van Dyck: Catalogue Raisonné*, 2 vols, Brussels, 1956

MI *Medallic Illustrations of the History of Great Britain and Ireland*, ed. E. Hawkins, A. Franks and H. Grueber, 2 vols, London, 1885; references are to the plate volumes, ed. H. Grueber, published from 1904

Millar, 1958–60 O. Millar, 'Abraham van der Doort's catalogue of the collections of Charles I', *Walpole Society*, XXXVII

Millar, 1970–72 O. Millar, 'The Inventories and Valuations of the King's Goods 1649–51', *Walpole Society*, XLIII

Millar, 1982 O. Millar, *Van Dyck in England*, exh. cat., National Portrait Gallery, London

NPG National Portrait Gallery, London

Ollard, 1979 R. Ollard, *The Image of the King. Charles I and Charles II*, London

OM O. Millar, *The Tudor, Stuart and early Georgian Pictures in the collection of Her Majesty The Queen*, London, 1963

Oman, 1974 C. Oman, *British Rings 800–1914*, London

P G. Parthey, *Wenzel Hollar. Beschreibendes Verzeichniss seiner Kupferstiche*, Berlin, 1853; Parthey's numbering system was also used in R. Pennington, *A Descriptive Catalogue of the Etched Work of Wenceslaus Hollar*, Cambridge, 1982

Piper, 1949 D. Piper, *King Charles I* (Historical Association, pamphlet 11)

Piper, 1957 D. Piper, *The English Face*, London

Préaud M. Préaud, *Dictionnaire des éditeurs d'estampes à Paris sous l'Ancien Régime*, Paris, 1987

PRO Public Record Office, Kew

RA Royal Archives, Windsor Castle

Raatschen, 1996 G. Raatschen, 'Plaster casts of Bernini's bust of Charles I', *Burlington Magazine*, CXXXVIII, pp. 813–16

RCIN Royal Collection Inventory Number

RL Royal Library (inventory of drawings)

Sainsbury, 1859 W.N. Sainsbury, *Original and unpublished papers illustrative of the life of Sir Peter Paul Rubens*, London

Samuel Cooper, 1974 *Samuel Cooper and his contemporaries*, exh. cat., ed. D. Foskett, National Portrait Gallery, London

Scarisbrick, 1994 D. Scarisbrick, *Jewellery in Britain 1066–1837*, Norwich

Schneider, 1956 H. Schneider, 'The Tower gold of Charles I', *British Numismatic Journal*, pp. 330–85

Seaby B.A. Seaby Ltd., *Standard Catalogue of British Coins. Coins of England and the United Kingdom*, London, 1990

Sharpe, 1992 K. Sharpe, *The Personal Rule of Charles I*, New Haven and London

Stopes, 1910 C.C. Stopes, 'Daniel Mytens in England', *Burlington Magazine*, XVII, pp. 160–63

Strong, 1972 R. Strong, *King Charles I on Horseback*, London

Ter Kuile, 1969 O. ter Kuile, 'Daniel Mijtens', *Nederlands Kunsthistorisch Jaarboek*, 20, pp. 1–106

Toynbee, 1949 M.R. Toynbee, 'Some early portraits of Charles I', *Burlington Magazine*, XCI, pp. 4–9

Verney, 1892 F.P. Verney, *Memoirs of the Verney Family during the Civil War*, 2 vols, London

Vertue Notebooks *Vertue Notebooks* published in seven volumes of the *Walpole Society*: I (XVIII 1929/30); II (XX 1931/2); III (XXII 1933/4); IV (XXIV 1935/6); V (XXVI 1937/8); Index (XXIX 1940/2); VI (XXX 1951/2)

Vickers, 1978 M. Vickers, 'Rupert of the Rhine. A new portrait by Dieussart and Bernini's Charles I', *Apollo*, CVII, pp. 161–79

Victoria & Albert, 1996 *Victoria & Albert, Vicky & the Kaiser*, exh. cat. ed. W. Rogasch, Deutsches Historisches Museum, Berlin

W&C C. White and C. Crawley, *The Dutch and Flemish Drawings in the collection of Her Majesty The Queen at Windsor Castle*, Cambridge, 1994

Ward-Jackson, 1992 P. Ward-Jackson, 'Expiatory monuments by Carlo Marochetti in Dorset and the Isle of Wight', *Journal of the Warburg and Courtauld Institutes*, pp. 266–80

Weigert R.-A. Weigert, *Inventaire du Fonds Français. Graveurs du XVIIe siècle*, Paris, 1939–

Williams, 1990 T. Williams, '"Magnetic Figures": Polemical Prints of the English Revolution', in *Heavenly Bodies. The Human Figure in English Culture c.1540–1660*, ed. L. Gent and N. Llewellyn, London, pp. 86–110

Wood, 1998 J. Wood, 'Peter Oliver at the Court of Charles I', *Master Drawings*, 36, no. 2, pp. 123–53

Concordance

RCIN	Exhibition number	RCIN	Exhibition number	RCIN	Exhibition number	RCIN	Exhibition number	RCIN	Exhibition number	RCIN	Exhibition number
2141	113	420048	10	443108	118	601657	76	601946	93	802226	68
28975	136	420049	11	443109	122	601664	77	602011	72	802330	65
28977	135	420050	14	443110	117	601738	83	602031	49	802335	69
28980	130	420055	12	443548	125	601776	101	602051	53	802347	70
28983	129	420059	16	601398	45	601780	84	602055	52	803454	82
28997	142	420060	18	601408	24	601781	96	602057	58	803457	67
29218	114	420897	20	601450	28	601785	81	602244	89	803503	59
33467	111	420942	13	601472	25	601789	57	602246	88	805140	66
35856A	112	420985	9	601474	26	601792	94	602249	87	805380	63
37055	133	421040	21	601477	114	601799	100	602638	90	1023277	109
43831	132	421355	17	601495	27	601811	102	602673	86	1023324	104
43832	127	421745	19	601497	34	601837	30	613349	36	1023524	108
43840	137	422099	22	601501	29	601846	37	654262	95	1027840	103
43847	143	422290	138	601511	35	601849	44	680496	31	1027841	105
43857	140	443080	115	601517	115	601851	55	680688	32	1046706	79
43860	134	443081	116	601523	41	601861	54	680689	33	1053560	110
63733	139	443089	124	601526	42	601863	51	750070	74	1098508	106
400571	6	443093	120	601527	43	601864	97	750073	75	1192852	107
404420	5	443095	123	601534	48	601865	98	750096	92		
404448	1	443097	121	601547	71	601870	56	751240	78	RL 17628	15
405296	4	443101	141	601549	50	601885	38	802201	60	RL 28706	23
405541	3	443104	128	601555	46	601886	39	802202	62		
405789	2	443105	131	601589	99	601888	40	802203	61		
405828	7	443106	126	601610	73	601914	47	802219	80		
405913	8	443107	119	601628	64	601937	85				

Index of artists and craftsmen

References are to exhibition numbers

Belcamp, Jan van (died c.1652) 4

Bernini, Gianlorenzo (1598-1680) 112

Boel, Cornelis (1576-c.1615) 27, 28

Bower, Edward (fl.1636-1667/8) 8

Briot, Nicolas (c.1579-1646) 118, 120-4

Clampe, Richard (fl.1640s) 75

Dalen, Cornelis I van 54

David, Jérôme (c.1605-1670) 51, 52

Delaram, Francis (fl.1615-1624) 34

Delff, Willem Jacobsz. (1580-1638) 48, 49

Dobson, William (1611-1646) 7

Doort, Abraham van der (c.1575/80-c.1640) 119

Dyck, Sir Anthony van (1599-1641) 2, 5, 6, 19-21, 56, 67, 71-7, 82, 99

Elstrack, Renold (1570-c.1625) 29, 30, 40

Faithorne, William II (1656-?1701) 100

Firens, Pierre I (died c.1636) 39

Gaywood, Richard (c.1630-1680) 76

Glover, George (fl.1634-1652) 57, 58

Gucht, Michiel van der (1660-1725) 101

Hilliard, Nicholas (1546/7-1619) 9

Hole, William (fl.1607-1624) 41

Hollar, Wenceslaus (1607-1677) 59-63, 65-70, 76, 80, 82

Hoskins, John (c.1590-1665) 16, 18

Jode, Pieter II de (1604-?1674) 99

Kijsel, E. 89, 90

Le Sueur, Hubert (c.1585-1670) 111

Lombart, Peter (1613-1682) 97, 98

Lovell, Peregrine (fl.1640s) 75

Marshall, William (fl.1617-1648) 80, 81

Mountain, Gerrit (fl.c.1623-1635) 26

Mytens, Daniel (c.1590-1647) 1, 2, 15, 48, 49, 53

Oliver, Isaac (c.1560/5-1617) 10

Oliver, Peter (c.1590-1647) 11-15

Passe, Simon de (?1595-1647) 31-6, 114-16

Passe, Willem de (c.1598-1636) 25, 42, 43

Petitot, Jean (1607-1691) 17, 19

Pot, Hendrick (c.1585-1657) 3, 23

Queboorn, Crispijn van den (1604-1652) 46

Rawlins, Thomas (c.1620-1670) 126-34

Roettiers, Jan (1631-1698) 141

Soutman, Pieter Claesz. (c.1580-1657) 71, 72

Streater, Robert (1624-1679) 74

Suyderhoff, Jonas (c.1613-1686) 71, 72

Voerst, Robert van (1597-1636) 56

Vorsterman, Lucas (1595-1675) 50